EGON
SCHIELE
1914·III

EGON
SCHIELE
1914.III

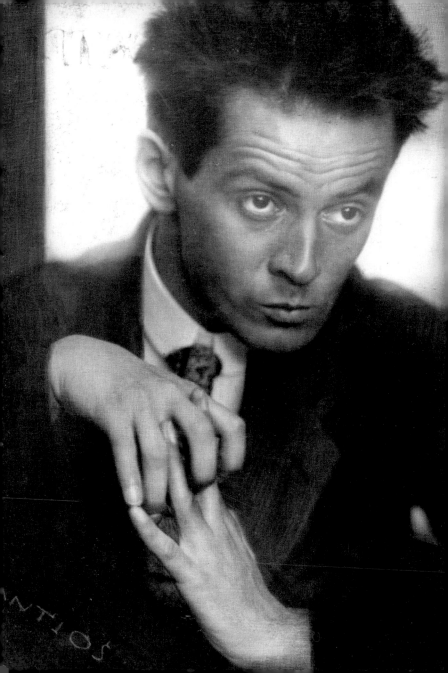

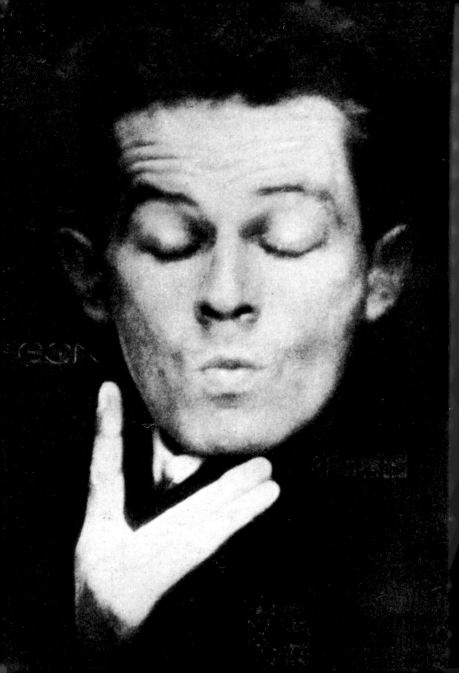

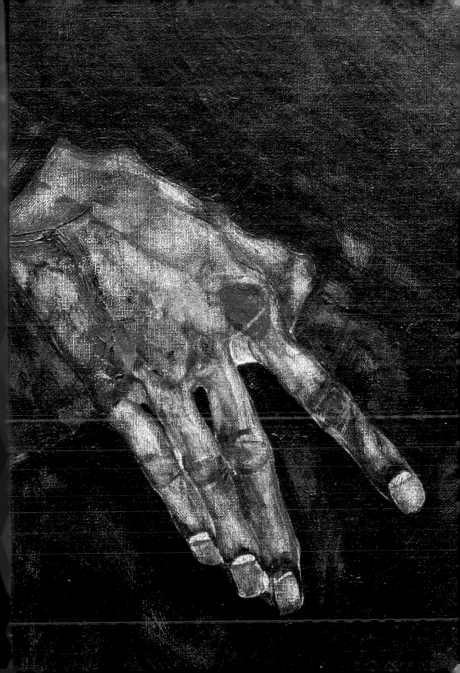

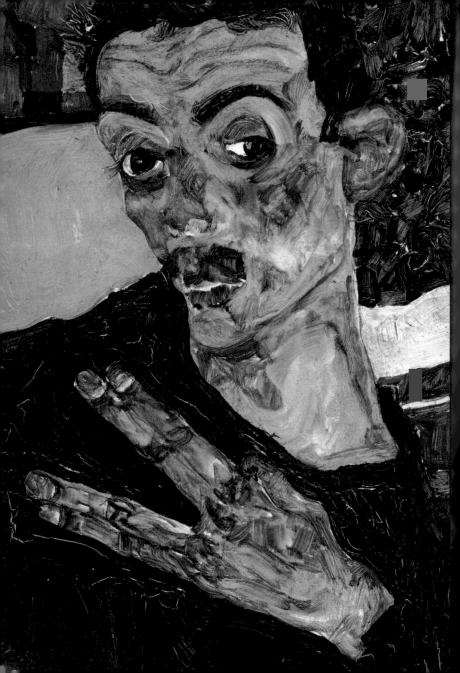

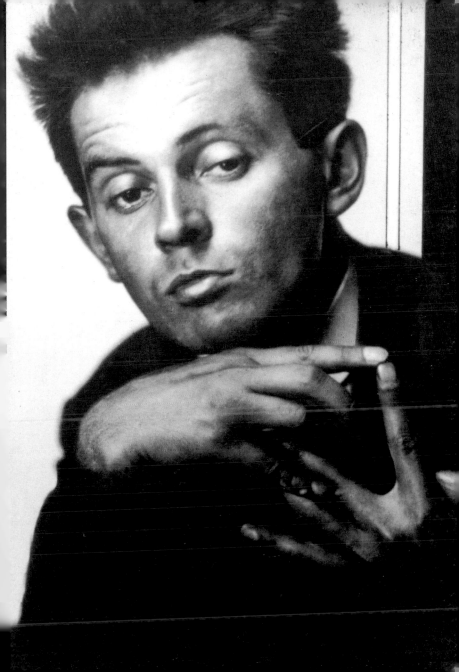

CONTENTS

EGON SCHIELE
THE EGOIST

Jean-Louis Gaillemin

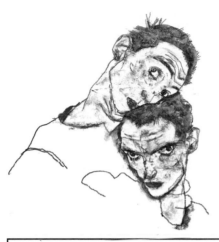

Thames & Hudson

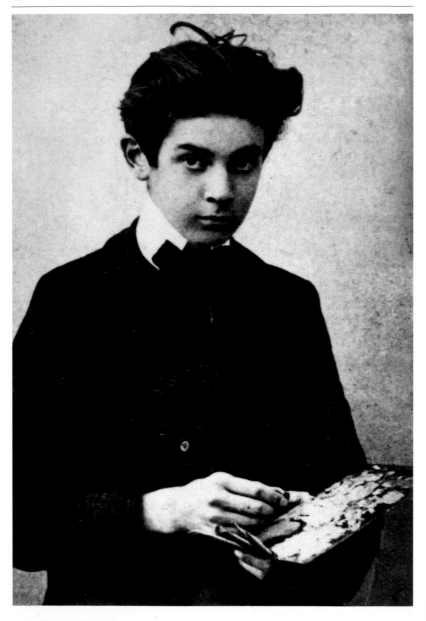

Born into an Austrian family of German origin who had moved to Bohemia, Egon Schiele was the product of a background that exemplified the Austro-Hungarian Empire in decline: Catholic, conformist, and devoted to the state. The family was reluctant to accept his artistic vocation, but with the death of his father he gained a certain independence, and at the age of sixteen he enrolled at the Academy of Fine Arts in Vienna.

CHAPTER 1

THE BEAUTIFUL BLUE DANUBE

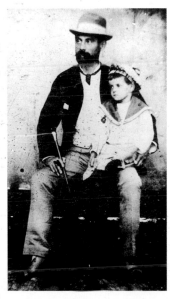

The young Egon was deeply affected by the premature death of his father, whom he idolized (right: Schiele with his father, Adolf, c. 1892). But his father had wanted Egon to be a railway engineer, and probably would have disapproved of his being an artist. (Left: Schiele in 1906, at the time of his enrollment at the Academy of Fine Arts in Vienna.)

"I was born on June 12, 1890 in Tulln on the Danube, of a Viennese father and a mother from Krumau. I took in the profound poetic impressions of childhood in a flat landscape with springtime avenues and raging storms. In those early days, it was as if I could already hear and breathe in the wonderful flowers, the silent gardens, and the birds. I could see myself reflected, all pink, in their shining eyes." In this brief transfiguration of a sinister landscape into lost happiness, we find all of Schiele: the embellishment of memories and a frenzied narcissism. The birds are nothing more than a convex mirror centered around the only important figure in this childhood paradise: himself.

The best present anyone could give little Egon was a new car brought back from Vienna for his miniature railway (below: a drawing by Egon, c. 1900, and opposite page, bottom, Egon c. 1894, holding a locomotive). He continued for a long time to be fascinated by the rhythms that delighted him in his childhood. In 1912—when he was 22—his friend the critic Roessler caught him in

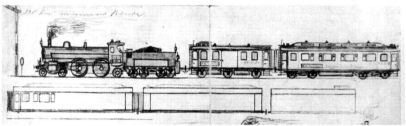

A Railway Family

Schiele spent an isolated childhood in the middle of nowhere, and there was nothing idyllic about the railway station in Tulln, where his family lived. Tulln was an insignificant place that only existed because it was a junction for railway lines running west to Bavaria and north, via a new bridge over the Danube, to Bohemia and Galicia. Not only was the railway an essential link between the various nations of the empire, it was also vital for strategic reasons. The railway uniform was military, and the full dress included a sword. Adolf Schiele was the station master at Tulln, and had come from a railway family. His own father was originally from Germany, and as an architect and engineer had built the line from Prague to Bavaria and moved his family into the Austro-Hungarian Empire. Adolf then met Marie Soukoup, who came from Krumau, a small town in southern Bohemia; she was the heiress of a family of

the act: "He had set up a little network in the middle of his bedroom and was making it go round and round, operating the switch, stopping the trains, hitching and unhitching the wagons . . . , but the strangest thing was the seriousness and virtuosity with which he imitated the various noises of the engine's siren, the departure whistle, the rumble of the wheels and the screeching of brakes, all the while commenting on the differences between the trains: 'This is a train coming into a station, this is one going into a tunnel.'"

property developers believed to be landlords in Vienna. The proud station master was handsome and charming, and spared no expense to keep up his lifestyle. Egon inherited this characteristic, and confessed to one of his first collectors, the journalist Arthur Roessler: "You must be right. I am a little careless with money matters; that comes from my father who suffered from the Austrian disease of living beyond his means. That explains why, although he was only a station master in a small place, he had his own team of horses and liked to affect a "noble" lifestyle. I have nothing against that, I understand very well why someone would want to go beyond his limits, even if it leads to disaster. It's better to fail than to go to seed [*versumpfen*]."

Egon's gift for drawing became apparent very early on; by his mother's account he was using a pencil and paper at the age of eighteen months. He had a passion for the railway, and drew minutely detailed scenes of it, based no doubt on his father's professional manuals and his miniature

Railways were a symbol of modernity, and of the unity of what was in fact a very unstable nation, otherwise known as "Kakania," a word invented by the novelist Robert Musil as a fierce attack on the importance attached by the double monarchy (imperial and royal) to uniforms, hierarchies, and resistance to change. Adolf Schiele loved to wear full dress military uniform on special occasions (above: a ceremony at Tulln station in honor of Adolf Schiele's 25 years of service, September 12, 1898. Adolf is third from the left; his wife Marie is standing a little further along, with their daughter Melanie). In civilian clothing, he played the elegant man and drove his family in a horse-drawn carriage.

train set, which grew to a whole network and took up the entire apartment.

Whenever members of the family traveled to Vienna, they brought back a new wagon or accessory. Egon's father already foresaw a future for him as an engineer, but soon realized that his son was spending more time on drawing than on his schoolwork, so he burned a precious book of drawings in the family's stove. There

Situated on a hill above the Danube, Klosterneuburg owes its fame to the Augustinian monastery whose neo-Gothic spire and baroque roofs dominate the town (below: a view painted by Schiele in 1905, seen from the school's art

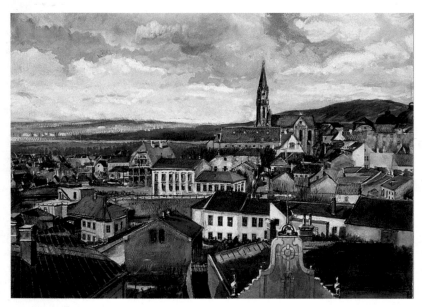

was no high school in Tulln, so at the age of eleven Egon was sent to the scientific high school in Krems, then on to another school in Klosterneuburg.

A Talent for Drawing

Like many young people from his background at this time, Adolf had "lived a little" and damaged his health before becoming engaged to a girl of seventeen. From the fact that the couple had two stillborn children and a daughter who died of encephalitis at the age of ten, it seems likely that he had passed his disease, probably syphilis, on to his wife and children. Three healthy children followed,

room). The monk Wolfgang Pauker, who was an art historian and was friendly with artists and writers, was the first to introduce Schiele the schoolboy to artistic circles in the capital, which was about 19 miles (30 kilometers) away.

however: Melanie, Egon, and Gertrud. Soon afterward, Adolf Schiele became more seriously ill, and was forced to take premature retirement. In 1904 the family joined Egon in Klosterneuburg, an attractive little town dominated by a vast baroque monastery.

In addition to his troublesome but harmless eccentricities—he insisted, for instance, that at every meal a place be kept for an invisible guest who had to be treated with respect—Egon's father began to have fits of rage. During one of these, he burned the precious share certificates that supplemented the family's modest pension. In 1905 he died of general paralysis. Egon, who revered his father, suffered more from his death than from his decline. This was the first and greatest drama of his life.

Egon took comfort not from his mother, whom he regarded as cold and insensitive, but from the company of his sisters—the elder one, Melanie, and his favorite, Gertrud, who was more mischievous and lively. She accompanied him on various escapades in Trieste, and posed for him in the nude without their mother's knowledge. The major event of 1905, however, was the arrival of a new drawing teacher, Ludwig Karl Strauch, who was the first to discover Egon's talent. A believer in modern methods, he was one of the few teachers at the Klosterneuburg high school who made life bearable for Egon at that institution, which he escaped from as often as he could. The benefits of playing truant could be seen in his little gouaches on cardboard, with their clean, decisive touch, bright colors, and well-composed forms. There are even some showing delightfully pretty flowers in full bloom, as if nature were still a refuge, a final moment of freedom before the demands of adulthood set in.

After her husband's premature death in 1905, Marie Schiele had to support her family alone, on a small widow's pension (above: *Portrait of Marie Schiele with Fur Collar,* 1907). Money problems poisoned her already difficult relationship with Egon, who found her cold and distant. She was, however, the only member of the family who believed in his star and encouraged him to enroll at the Academy of Fine Arts, against the advice of her brother Leopold Czihaczek, whom she had named as joint guardian of her son.

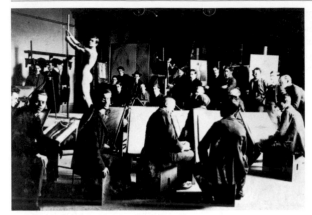

As a result of his frequent truancy and poor performance at school, Schiele was told that he had to repeat a year, and managed to persuade his unhappy widowed mother that he should have a career as a painter.

She tried for a while to find him a position at a cousin's photography studio, but to no avail. The next step was to apply for a place for him at the Kunstgewerbeschule (School of Arts and Crafts), in the hope that this establishment, where Gustav Klimt had studied, and which was a breeding-ground of talent for the Wiener Werkstätte (the recently opened studio in Vienna), would at least "be of some use to him."

The teachers at the Kunstgewerbeschule were astonished by Schiele's talent for drawing, and advised him to apply to the Academy of Fine Arts. He was accepted, and when he entered the academy at the age of sixteen, his guardian and uncle, Leopold Czihaczek, who had previously done everything he could to discourage him, offered him lodgings and obligingly offered his services as a model. In order to keep a close eye on her son, Marie Schiele moved to Vienna. The academy was strict: as in all official art schools at the time, its students were required to do a laborious apprenticeship, first drawing

Schiele's three years at the Academy of Fine Arts enabled him to master anatomy and perspective and to perfect his drawing (left: a life-drawing class, with Schiele in the background on the left, facing the model). He was not at all popular with Christian Griepenkerl, who was a society portraitist and historical painter, and is believed to have said to him: "For pity's sake, never tell anyone that it was I who taught you to draw." Vacations with Uncle Leo were an opportunity to paint quick "on-the-spot" sketches in oil (below: Egon Schiele and his Uncle Czihaczek on a day out on the outskirts of Vienna, 1908).

casts of ancient sculpture, then nudes, before they were allowed to touch a paintbrush.

Egon's teacher, Christian Griepenkerl, took a dislike to this over-gifted student who always "cobbled something together" at the last minute; their relationship was strained, but nevertheless it was the academy that gave Schiele a technique that he would transform into an instrument of invention.

Below: interior of the Secession group's 14th exhibition in Vienna in 1902. The show's theme was Beethoven, and the décor was designed by the architect Josef Hoffmann. Sitting on a "primitive" armchair is Gustav Klimt, wearing

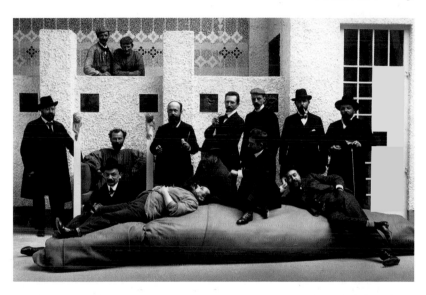

The Temple of Art in Vienna

Private galleries were rare at this time, and it was difficult for a student of fine arts to get to know contemporary art. It was now three years since the "Klimt group" had parted company with the Vienna Secession, an association of artists in revolt that had been founded in 1898 and whose headquarters were, ironically, located right behind the Academy of Fine Arts. Every year it held two exhibitions, showing the best new work in Europe, not only in painting and sculpture, but also in the decorative arts. Sometimes the exhibition was organized

his work clothes and surrounded by Anton Staub, Adolf Böhm, and the main Secessionist artists who collaborated in this collective installation. At his feet, Koloman Moser, at that time a decorative artist; above the artists, two workmen who are helping to mount the exhibition. The works of art are inserted into the architectural structure.

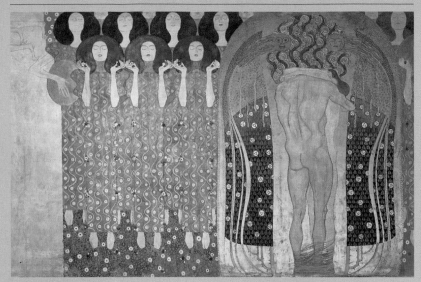

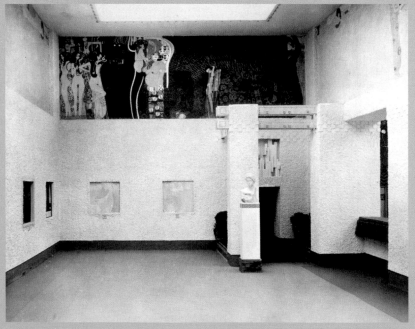

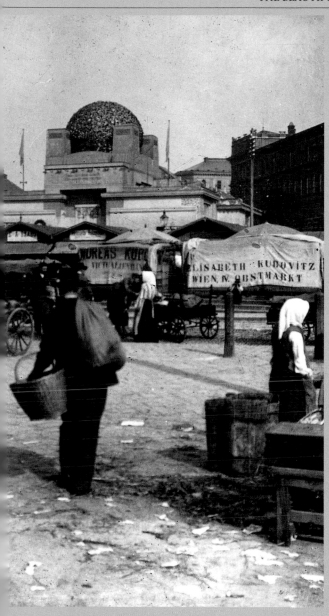

On the Karlsplatz in Vienna, home of the Naschmarkt, a popular fruit and vegetable market (left, in 1899), stands the white and gold Secession building, headquarters of the artistic association of the same name, and built in 1898 by Joseph Olbrich. Nicknamed the "cabbage top" by regular customers at the market, its openwork dome was meant to echo the dome of the Karlskirche, which was directly in line with it. Erected on a bare piece of land on the edge of the square, the Secession ironically turned its back on the neoclassical red brick building of the Academy of Fine Arts (on the right in the photo), where Schiele studied from 1905 to 1909.

View of the first gallery at the *Beethoven* exhibition in 1902, where Klimt's cycle on the composer was displayed (opposite page, below). A three-part fresco runs along above the plaster wainscot: the knight's quest must first triumph over the group of "hostile forces" before reaching its apotheosis in an early version of the famous *Kiss* of 1908. Sheltered by a gilded matrix that signifies their rebirth, the primordial couple, enclosed within their happiness, send out their kiss "to the whole world," in the words of the Ninth Symphony's "Ode to Joy."

around one monumental work, such as Max Klinger's sculpture *Beethoven* in 1902, which was installed right at the center of the Secession. Before that holy of holies came a frieze by Gustav Klimt, dedicated to the Ninth Symphony and summing up the Secession's aesthetic: in it the new "virtuous knight," having fought the hostile forces of the modern world, found happiness in a symbolic kiss given to a new Eve. Around this couple, frozen in eternal bliss, a choir of angels sang Schiller's "Ode to Joy," sending out "this kiss to the whole world."

In 1903, Josef Hoffmann and the painter and designer Koloman Moser founded the Wiener Werkstätte ("WW") or "Vienna Workshops," which was modeled on the British Arts and Crafts guilds. Their aim was to create high-quality craft studios that would design and create interiors "for our time."

Discovering the Wiener Werkstätte

The Klimt group's departure in 1905 had emptied the Secession of its contents, which meant that Schiele's first opportunity to see the latest works of Klimt and the WW came in 1908 with the Kunstschau (Art Show), a large exhibition at which the work of 179 artists in all was shown in 54 rooms or pavilions. No area of life escaped the attention of the WW; from baby clothes to gravestone designs, interspersed with jewelry, tableware, posters, a model house, fashion and theater, children's toys, and cakes (designed by Hoffmann and Moser), everything was based on the same aesthetic of chic, austere sobriety, in white, black, and gold.

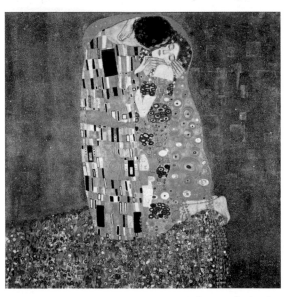

Sometimes called *The Garden of Love,* Gustav Klimt's *The Kiss*—perhaps his most famous work—sums up the aesthetic of the 1908 Kunstschau, an event organized by Klimt and his friends following their much-publicized departure from the Secession, ten years after it was founded. The couple are merged into one figure, and can only be told apart by their ornamentation, black and rectangular for the man, round and colorful for the woman, which is a newer version of a long-established type of sexual symbolism. Intellect and strength communicate with emotion and life in a utopian world with no horizon or terra firma.

The great Klimt himself showed sixteen of his latest works, centered on one key painting, *The Kiss,* which was a reprise of the 1902 Beethoven theme and was sometimes called *The Garden of Love* by contemporaries. Here again the lovers are isolated in their happiness, an abstract, protected space on the edge of a gold-studded chasm. Their bodies are hidden under shimmering garments, which merge with the cover that protects them. As in an icon, all that can be seen of the couple are their faces and hands.

A "Wildcats' Cage"

The Kunstschau would have been a gilded cage had Klimt, always anxious to promote new forms of artistic expression, not had the idea of inviting along a troublemaker: a young twenty-two-year-old painter, Oskar Kokoschka, who had studied at the Kunstgewerbeschule. "Nothing is missing from this Barnum of art," wrote a belligerent critic, "not even the wildcats' cage."

The wildcat had his own room, in which he exhibited a few drawings, a storybook, and some tapestry cartoons that brought roars of disapproval from the critics; his heroes from a bygone age were "Oceanians, Egyptians, Indians," or, at any rate, savages of some kind, whose oversimplified bodies were placed on flat, uniformly colored backgrounds, with no concern for perspective. In his book *The Dreaming Boys* he evoked the torments of puberty and presented Eros in the figure of a werewolf: "I shall devour you, men, women, and half-awake children, I the werewolf, furious and in love, nestling within you."

Intended to demonstrate the union between fine art and the decorative arts, the Kunstschau of 1908 created an all-embracing aesthetic environment that aimed to blot out the harshness of real life. This idealism was denounced by some young artists such as Oskar Kokoschka, who was invited to take part by Klimt himself. As well as showing a few paintings, "OK" dreamed up a primitive play, *Murderer, Hope of Women,* for the show's makeshift theater. His poster took up the theme of Klimt's *Kiss,* but here the man was flayed alive, bleeding, and resting in the woman's arms like the Christ figure in a Pietà.

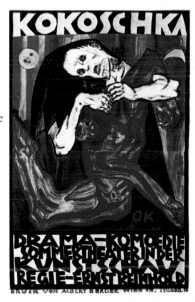

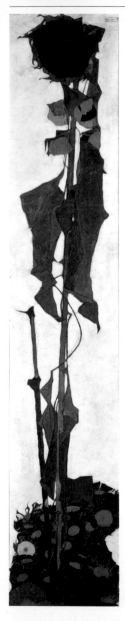

Better still, Kokoschka used the Kunstschau's open-air theater to put on his first play, *Murderer, Hope of Women,* a "prehistoric" drama in which the urges of love and death tore apart gaudily colored bodies. The poster was like a parody of the *Kiss* of 1902, but here the man was flayed alive and red with the blood of his urges, and lay, Christlike, on the woman's knees.

It is not hard to imagine what a godsend the Kunstschau must have been for a second-year student at the Academy of Fine Arts. At a time when Schiele was finding tough academic discipline hard to bear, the examples of contemporary art at the exhibition showed him several paths he could take, and Klimt in particular had a considerable impact on him. A year later, the 1909 Kunstschau enabled Viennese artists to discover some of the great names from abroad: Amiet, Barlach, Bonnard, Denis, Gauguin, Matisse, Toorop, Vallotton, Vlaminck, Vuillard. This time Schiele, no doubt with the help of Hoffmann, joined Kokoschka in the wildcats' room with four paintings, all very much in the style of Klimt, which failed to draw any attention. Nevertheless, Schiele was encouraged by having taken part in the exhibition, and having left the academy in June after a final walkout on Griepenkerl, he decided to join with those of his friends who had followed him in

In 1909, Schiele was invited to the second Kunstschau, where he exhibited works insipired by Klimt. One of these, *Sunflower II* (1909), had already been shown in the Kaisersaal in Klosterneuburg. Rising out of the soil, which is studded with flowers in the style of Klimt, this black flower with petals burned by the sun shows early signs of the grim, acerbic, distorted vision

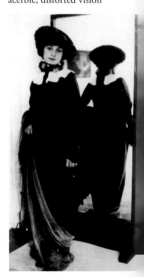

of the dissident disciple. Above: Gerti Schiele wearing a Wiener Werkstätte outfit in front of the large mirror in her brother's studio, c. 1911. The pretty, mischievous "little sister" posed for the artist while still very young, without her mother's knowledge.

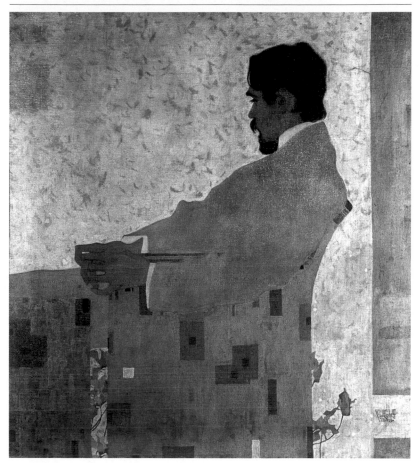

forming a new artists' group, the Neukunstgruppe (New Art Group), which in December organized a collective exhibition in a private gallery. The manifesto, written by Schiele, announced the group's radical break with the past: it would follow no precepts but its own. As if to avoid any misunderstandings that might result from the group's name, he wrote; "Art always remains the same, there is no such thing as new art. There are new artists . . . but very few. The new artist is and must necessarily be himself, he must be a creator and must build the foundations

Painted in homage to Klimt, *Portrait of the Painter Anton Peschka* (above, 1909) places the figure of Schiele's friend and future brother-in-law in an armchair wedged into the composition by an interplay of rectangles that is disrupted by the rebellious frieze of red flowers.

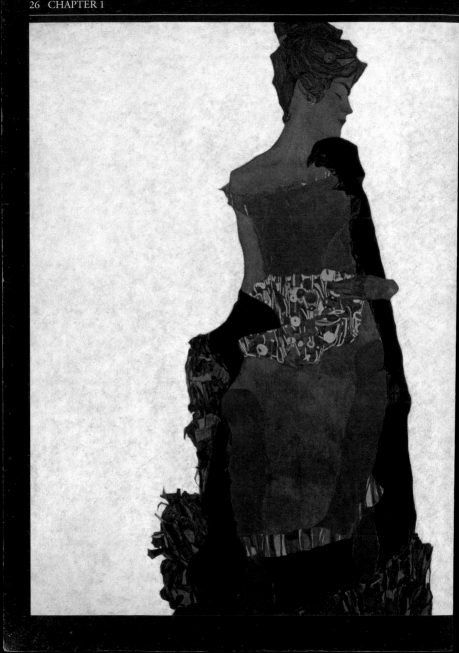

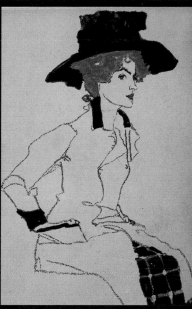

As both a disciple and a protester, Schiele adopted Klimt's style of composition for his portraits by dissolving the outline of his models into their ornamental settings, while at the same time making these hybrid, disquieting figures stand out against the gray background of his early portraits (opposite page: *Portrait of Gerti Schiele*, 1909). The closed eyes and profile dissociated from the frontal pose add a further note of enigma to the image.

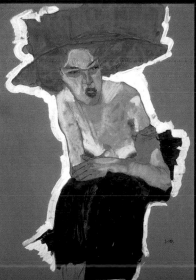

The other two portraits here show Gertrud wearing Wiener Werkstätte fashions. Whether as elegant and impassive as a fashion plate (top: sketch for a postcard for the Wiener Werkstätte, *Portrait of Gerti Schiele in a Large Hat*, c. 1909), or caught in a vindictive moment by her brother, who may have asked her to put on this fishwife's expression (bottom: *The Scornful Woman*, c. 1910), she entered into the game of posing. These elliptical graphic treatments did not go down well with the Wiener Werkstätte, which rejected the three watercolors proposed by the artist as designs for postcards. Schiele, they said, did not have the fluidity required by the "decorative arts."

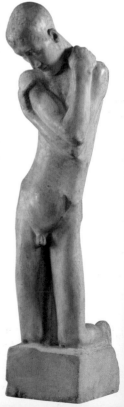

In borrowing from Klimt the posture of the hysterical woman in *Medicine* (left, 1900–1907) for his first nude self-portrait (opposite page, *Nude Study*, 1908), Schiele was admitting his preference for the master's "pessimistic" period, when he was breaking away from institutions and official thinking.

absolutely on his own, directly and without relying on tradition or the past. Only then is he a new artist. Let each one of us be himself."

A New Art: Introspection

Behind the apparent banality of this call for a clean sweep, one can detect the desire for the "foundation" of a new art to be derived from the existential experience. It would he hard, without using the word itself, to find a better way of describing what would come to be known

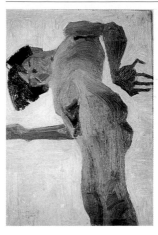

as Expressionism. "In every era the artist shows a piece of his life, and it is always through a great experience in the individual being of the artist that a new era begins." Far from following accepted ideas, Schiele turns in toward what he has that is most tangible: his own body. Whereas a painter such as Klimt suppressed his own personality and never let it appear in the foreground, Schiele and the painters of his generation—Kokoschka, Gerstl, and also Oppenheimer—gave themselves over to introspection. In homage to Klimt—one might almost say as an offering to him—Schiele, for the first time, stripped himself naked. For this first in a long series of self-portraits, he modeled himself on a typically Klimtian figure, the woman floating in the troubled space of *Medicine* (sometimes also known as *Suffering*). Schiele took on the hysterical posture of this helpless, fragile figure, isolated from the rest of humanity, and viewed himself from below, as if his mirror was on the ground. In the same year he showed himself on his knees in the nude, in the same kneeling posture as the lovers in the *Kiss*—a work that haunted him and that he repeatedly tried, whether secretly or overtly, to paraphrase.

Omnipresent in the interiors of Viennese aesthetes, George Minne's sorrowful *Narcissus* (opposite page, bottom: *Young Man Kneeling,* 1898) introduced a slight note of dissonance to the harmonious décors of the Wiener Werkstätte. Both Egon Schiele and Oskar Kokoschka made use of this spindly figure to embody their new ideal: the man made anxious by his body and instincts (below: *The Girl Li and I,* 1906–8, illustration for Kokoschka's *The Dreaming Boys.*

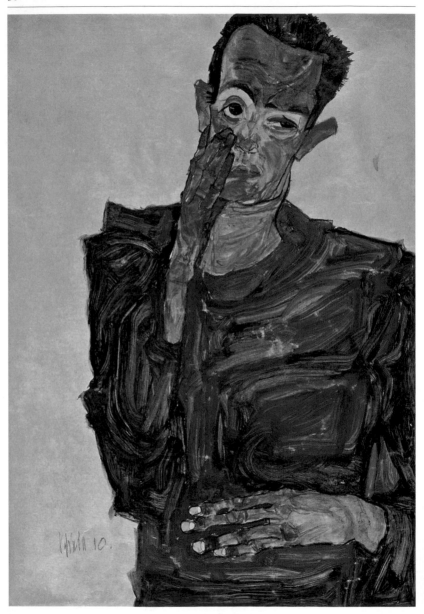

Torn between his ardent love of life and his terror of it, the teenage Schiele reconstructed the world on the basis of himself. His distorted, dislocated, mutilated body became the experimental field from which he drew his models. This descent to the borders of pathology enabled him to combat the forces of death by reconquering form. From this came the hope of a new birth, which in turn reinforced his narcissism.

CHAPTER 2
ME, ME, ME

As an actor faced with himself, like his Austrian predecessor Franz Xaver Messerschmidt, Schiele went from darkest melancholy (opposite page: *Self-portrait with Hand to Cheek,* 1910) to the most disarming suavity (right: *Self-portrait with Hands on Chest,* 1910). Was he just pretending? It was a risky game, where the player was in danger of losing himself.

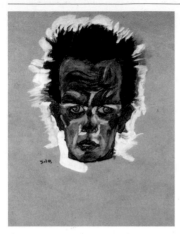

The Dissection of Bodies

Rarely has the birth of a talent been so sudden. In a few months toward the end of 1909, Schiele found himself; having thrown off the glittering, many-colored mantle of Klimt, he discovered his own flesh. The tabula rasa he dreamed of was an operating table on which a body experimented on itself by separating and then dissecting its own limbs. Rather than the smooth, white forms of plaster casts, or the eloquent postures of models, he preferred to look for the signs of a primordial language on himself. The unique ability to view his own body in detail made it possible for him to avoid conniving at the illusion created by a model's pose. The epidermis lost its seductive power when it was drawn tight by bones that jutted out at the joints. The smooth skin of the beautiful young man of twenty was now just a hollow mass of creases and bumps. The serpentine figure was replaced by nervous zigzags, and the elegant hand gestures by a clump of gnarled fingers. The eye was drawn to the acute- or right-angled formations of the pelvis and shoulders. The truncated body was stretched and set in a catatonic tension that made the hair on the head and body stand on end.

Never before had the criteria for the beauty of the nude body, as codified by Winckelmann and the academy, been flouted to this extent. The "calm

Under the keen gaze of the artist, the slightest blemish on the body is scrutinized and becomes rich in meaning. So, for example, the wrinkles on the brow in this self-portrait of 1910 (left), which as they are drawn could represent the ill humor of a moment or a permanent mark of destiny. Below: abused, ravaged and tortured, the body in *Grimacing Man (Self-portrait)*, 1910, bears witness all the more clearly to its irreducible enigma. These were the kind of experiments that sixty years later would be tried out by the Vienna Actionists.

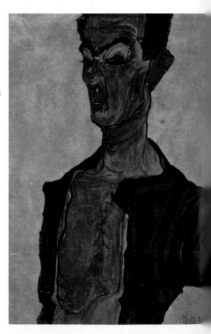

grandeur" of antiquity gave way to the hysterical agitation of a beetle, while "noble simplicity" was transmuted into ignoble contortions. Instead of the "unity" of a body caught "all at once," there were now convulsive rhythms that the eye ran over in panic. Egon Schiele was seized by the same helpless confusion that Robert Musil's Young Törless felt when he looked at his friend Beineberg: "If he imagined a nude body, it was almost impossible for him to hold on to the idea of a calm slenderness, instead of that what instantly appeared to him were contorted movements, a dislocation of the limbs, a distortion of the vertebral column, as one sees in all representations of the martyrs and grotesque fairground sideshows. Even the hands, which he could have imagined in elegant poses, seemed to him to be agitated right to the fingertips. And it was particularly for those hands, which were Beineberg's most beautiful feature, that he felt the greatest revulsion. There was something obscene about them."

The Search for the Self

When we see the artist face on, his bulging or closed eyes exclude any possibility of collusion. The mouth, sometimes toothless, is in a grimace, and the unkempt hair radiates a sense of terror that is emphasized by the exaggerated contractions in the forehead. The navel and breasts are signs of finiteness and ambiguity, pinning together the dismembered torso. On the few occasions when the penis is shown it is either reduced to a shapeless, indistinct clump, or shown erect, brightly colored, and painful, turning the artist into a sad Priapus. The colors, often applied after the work was finished, add a final touch to this general sense of

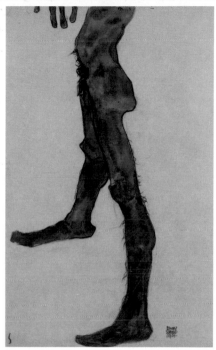

The truncated composition here immediately brings what is in view sharply into focus (*Male Nude, Torso,* 1910). Cut off from meaning, the anatomical detail offers up its monstrosity to the artist's unforgiving eye. Hair on the body, creases in the skin, nodules, veins, foreshortenings, and distortions all force us to see what is generally a mere concept devoid of content: the ideal body, epitomized by the beautiful, smooth, undulating contour of the classical aesthetic.

dislocation. The meanders of the gouache over the skin give it a fantastical cartography.

Nude Self-Portrait, a large canvas from 1910, shows the intentional incompleteness of this quest for the self; we see the outline of an experimental body whose flesh tints, from greenish-brown and dirty yellow to orangey-brown and dark red, indicate the erogenous zones around the genitals, navel, and abnormally enlarged breasts. The empty eye-sockets shine red like the eyes of a werewolf. We cannot tell for sure whether these are experiments or neuroses, fantasies, or temptations.

A few knowing self-portraits in which Schiele flashed the onlooker a provocative look may give the impression that everything was "under control," but the Symbolist compositions of the transition period of 1910–11 showed that these tensions, whether intentional or otherwise, were producing images suggesting the fragmentation of the self and a vision of delirium. Death was threatening to stifle the life force; the artist's double was rearing up like an evil genius; and the sleeper, split up into several bodies, could see the amorphous shape of a nightmare invading his bedroom.

A Distorted Vision

Not content with ill-treating himself, Schiele also involved his models in these experiments in distortion. They were not professionals with a conventional repertoire, whom in any case he would have been unable to pay, but people in his close circle. He usually painted men from the back, showing the bony details of the spinal column, and giving them very prominent shoulder blades and pelvic bones. Their heads suffered especially badly,

With the eyes of a faun, the artist—seen here drawing a nude model in front of a mirror, 1910—examines his model wearing just her hat and stockings, and draws with a light but jerky touch. Opposite page: in *Nude Self-Portrait* (1910), the artist's flayed body with its bulges and hollows is nailed to the gray canvas by the red points of the genitals, breasts, and eyes. Judging by the cadaverous colors, it seems that the body is not just distorted and mutilated, but decayed as well.

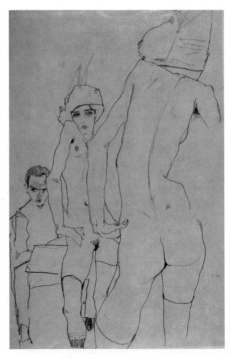

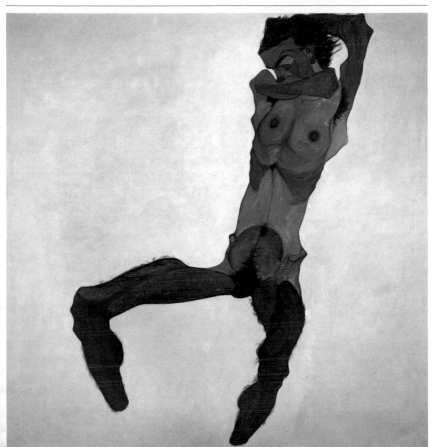

being masked by a flat patch of color, cut off, or violently pushed down onto the shoulders, while the arms and legs were mutilated or sliced off by the edge of the canvas. The genitals were barely suggested and ambiguous, and in some cases these extended, truncated, asexual bodies were little more than an interplay of abstract lines. The absence of a floor or any accessory, such as a bed, chair, or stool, accentuated the enigmatic nature of the postures even further.

Schiele's nude portraits of women were not immune to this distorted vision. Based on his sister Gertrud

Reduced to the status of an ideogram in a primitive language, or fragments sketched in an imaginary morgue, the body reinvents itself according to random postures and viewpoints (following pages: left, *Seated Male Nude from Behind*, 1910; right, *Male Nude with Raised Hands*, 1910)

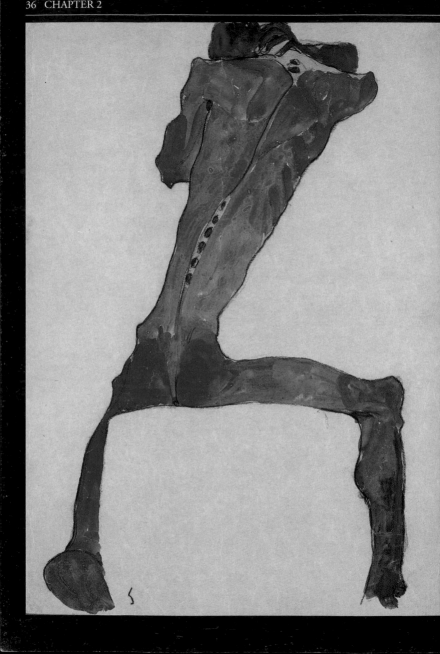

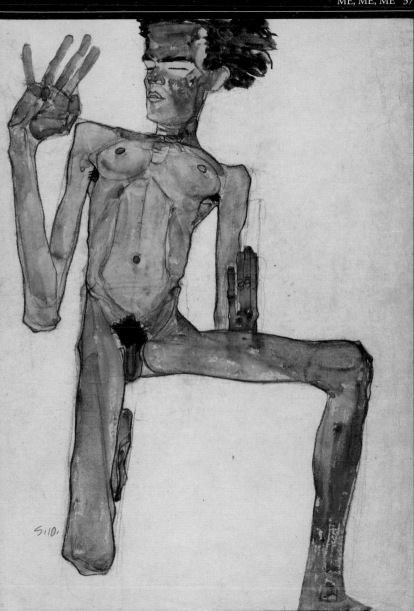

or models no doubt provided by Klimt, their
bodies were lean, simplified, and tense. Klimtian
plump curves were banished, as in the astonishing
Schiele Drawing Nude before Mirror, where the
woman's torso in the foreground bends from the
hips at right angles.

These nudes were both "unfeminine" and
"masculine," as the wife of Heinrich Benesch,
one of Schiele's collectors, would uneasily put
it. This was an artist who deliberately failed
to differentiate between the sexes, and also
recruited young boys and girls from the poor
areas of the city, who for a few pennies were
willing to display their scrawny anatomies.
Some of these children adopted Schiele's favorite
postures; standing or kneeling, both boys and
girls modestly wrapped their arms around their bust and
shoulders. The painter looked for extremes; in 1911, the
gynecologist Erwin von Graff allowed him to sketch the
pregnant women and newborn babies in his hospital

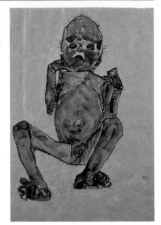

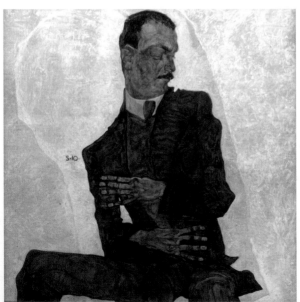

Pregnant women,
infants (above:
Newborn Baby, 1910),
sickly children, friends or
personalities in Vienna—
none of Schiele's models
escaped his clinical
vision, whatever their
age or sex. Even the
portraits have the cruelty
of a dissection (left:
Portrait of Arthur Roessler,
1910). Roessler was the
first critic to have written
about Schiele. With his
limited understanding
he was later unable to see
how the artist's work had
evolved, and also wrote
fake memoirs, which
contributed to the legend
of Schiele as an "accursed
artist." This portrait of a
man turned in on himself
and with his eyes shut
may suggest that Schiele
sensed these limitations
in advance.

department. The sketches were uncompromising portraits of miniature people whose grotesque impotence seemed to be the criterion for human beauty, and of women caught unaware during a consultation, pathetic silhouettes with their arms crossed over their bellies or stretched out in a gesture of helplessness.

When Artists Immolate Themselves

Schiele's portraits also became involved in this autistic vision. There were portraits of his painter friends, such as Max Oppenheimer, who was caught standing affectedly at attention, and returned the compliment with an emaciated effigy of a young cock. He also painted his future brother-in-law Peschka, but most striking of all was the 1910 portrait of his friend Arthur Roessler, the leading critic and collector, which seemed to be made up of different pieces patched together, with the body seen face on and the head in profile. By some strange anatomical acrobatics, the left arm is pulled in against the bust, and both of the critic's flat, enormous hands are reduced to four fingers and frozen in a gesture of self-protection. This critic could be either a visionary or a blind man trapped within the rosy aura of a view of Schiele, which he would repeat endlessly despite the artist's evolution.

Whereas Klimt transformed the great ladies of Vienna into madonnas or goddesses, dissolving their forms in abstract settings of extraordinary elegance, Schiele treated his models severely, projecting them in condensed form on to a background with no points of reference and devoid of all accessories. Naked and fragile despite their clothes, they received

Otto Wagner (below) was the father of the Secession generation, and liked to encourage young talent. In 1910, he had just completed the Post Office Savings Bank, a building that would establish his reputation as a pioneer of modern architecture. He believed that Schiele's work as a portraitist could quickly bring him fame and prosperity. In fact, the painter had to wait until 1917 to make his name in this field.

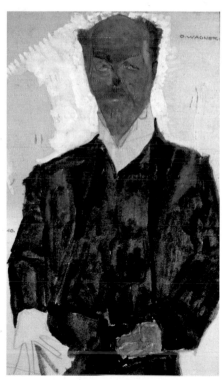

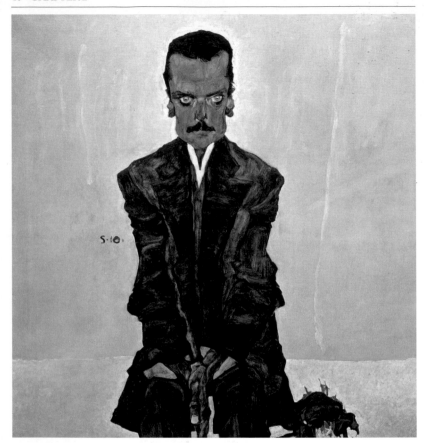

a new identity, which made them part of the Schielian brotherhood.

Eduard Kosmack looks straight at us with ecstatic eyes, concentrating all his strength in his gnarled hands, which are placed between his thighs, and tries to hypnotize us; his huge forehead is marbled with wrinkles that burst out like sparks. The electric tension is accentuated by a white nimbus around his head and by the sparklike orange petals of an artificial flower on the ground.

The gangling figure of the painter Karl Zakovsek crosses the canvas diagonally, with one arm supporting

The Viennese publisher Eduard Kosmack (portrait above, 1910) brought out several journals on architecture and interior design, such as *Der Architekt* and *Das Interieur,* a "Monthly on Decoration and the Decorative Arts," of which Arthur Roessler was the editor-in-chief.

his head like a Christ suffering insults, and the other arm, with its skeletal hand, hanging loose and dangling in the void, as if the puppeteer had let go of the puppet's strings. Only close friends could accept these images, which were as much of the painter's psyche as they were of his subjects. Around the same time another collector, Oskar Reichel, refused his portrait, and the master of the Secessionists, architect Otto Wagner, grumbled at the long sittings he had to endure.

Once a friend of Schiele's at the Academy of Fine Arts, the painter Karl Zakovsek was one of the founders of the New Art Group. Schiele's oil portrait of him (below, 1910) was preceded by numerous drawings.

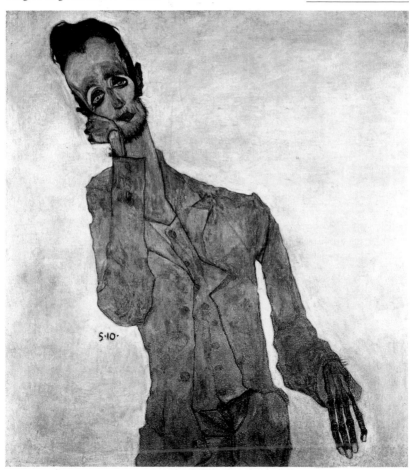

In All "Innocence"

Schiele's first personal exhibition took place in April–May 1911, and was disconcerting for a Viennese public accustomed to the urbane appeal of the Secessionists. The female nudes were considered particularly shocking. The artist's earliest critics, Arthur Roessler and the painter Albert Paris von Gütersloh, were well aware that his work would be regarded as peculiar and not very "nice," and so portrayed him as a visionary, a chosen one, whose aim was to communicate his terrible message with the greatest possible honesty. Using a combination of psychoanalytical ideas and mystical vocabulary, Gütersloh saluted Schiele as the artist who had had the courage to come as close as he could to

Throughout his life, and especially after Schiele's premature death, Arthur Roessler fought for the artist's reputation (top left, first issue of the review *Bildende Künstler*, Vienna-Leipzig, 1911, of which he was the editor-in-chief).

Distortion, prominent bulges, and incongruous settings were used by the artist to reconstruct bodies without reference to the over-simple categories of age and sex (below: *Man Reclining with Green Towel*, 1910).

himself, so that he could paint "the terrible guests of the night of the soul" at the moment when they appeared. He heard the cry of the Great Pan, and seized the being of things at their birth, before they were swept away by the endless circle dance of words. Schiele was an "Orpheus of modern times," who in order not to be torn apart by the terrors that surrounded him, had learned to translate them into clear forms and precise colors.

For Roessler, Schiele's withdrawal into himself entailed a sacrifice: "His art is monological, and from a certain point of view demonomaniacal. Many of his images are the materialization in a darkened consciousness of dazzling apparitions. Behind the warm life of the blood he senses destiny whispering, and gives this feeling a palpable expression of almost pious naïveté." Innocence, the "noble simplicity" conferred since the neoclassical era on the human body, was now transferred to the artist's soul, which in all "innocence" conveyed scenes of terror and obscenity. This was a romantic vision, adapted to the age of hypnosis and psychoanalysis. *Sturm und Drang* (Storm and Stress), had given way in Freud's time to *Trieb und Drang* (Drive and Urge): "His paintings are the formal manifestations of nervous gesticulative impressions. They come into being instinctively and by pure momentum, without posing, without bitterness, without hope."

The artist was like a sleepwalker who, being unable to "narrate," gave a precise form to the faces of madness, vampirism, and death that he had glimpsed, and a

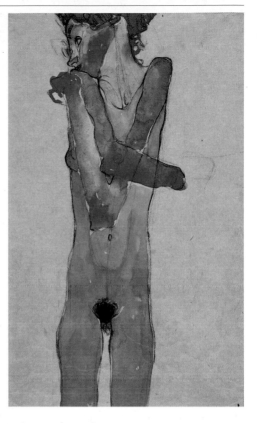

Schiele's first and highly precocious model Gerti is seen here adopting the pose of George Minne's kneeling young man, with a modesty and reserve that are emphasized by the arms crossed in a gesture that is both protective and defensive. The negation of the chest and the graphic treatment of the genitals reinforce the ambiguity of puberty.

physical body to the "rottenness of the soul." In complete contrast to the hedonism of Klimt and what was accepted as good taste by the Viennese elite, this exaggerated emphasis on the "sorrowful" placed Schiele, according to Roessler, in the Gothic tradition of painting. For Roessler, who was a writer and in 1913 published *Stimmung der Gotik* (The Gothic atmosphere), Schiele the "neo-Gothic" was a modern "man of sorrows," offering himself to the multitudes.

The Viennese Malaise

It may seem from this that Schiele was entirely at odds with his contemporaries, a unique comet in the serene sky of the Kunstschau, whose treatment of bodies and dark, religious, even occult themes was peculiar to him. We should, however, remember first of all that the desire expressed by the "Klimt Group" for harmony between major and minor arts, artists and amateurs, painting and music, arose above all from a desire to camouflage the terrible social reality of the Belle Époque in Vienna, and also the

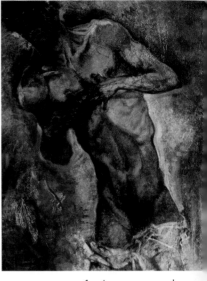

psychological malaise that prevailed during that period: the same malaise that was being analyzed at that time both by Sigmund Freud and by Otto Weininger in *Sex and Character* (1903). Behind the apparent harmony of Klimt's great portraits there was a kind of crack; the flesh was ennobled, tamed, and dissolved into its ornamental setting, but it rebelled in the eyes, the creases in the lips, and

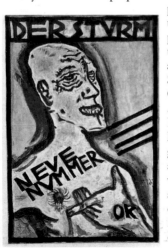

A rtists now portrayed the body as sorrowful, rather than with the veneration shown for it by the princes of painting in previous generations, such as Hans Mackart or Gustav Klimt. Convinced that they were the interpreters of the world's mysteries, Expressionist artists offered themselves up as new saints of a new religion (above: *The Bleeding Man* by Max Oppenheimer, 1911; left: poster for the cover of the magazine *Der Sturm,* by Oskar Kokoschka, 1910). This could be seen as excessive individualism, or alternatively as the expression of a malaise that a few years later would lead to the vast collective suicide of World War I.

the clenched hands. The great paintings of the "Golden Age" emanated a sense of anxiety, which Klimt tried to eliminate from his large mosaic in the Palais Stoclet in Brussels, completed in 1911, where *The Kiss* was now no more than a sketch diagram of happiness, frozen within the precious materials of the Wiener Werkstätte craftsmen.

It should also be said that Schiele was preceded and accompanied not only by Kokoschka, but also by Max Oppenheimer, four years his senior, who in 1911 painted portraits in a similar style, with closed eyes; huge, tortured hands in enigmatic positions; and haloes around the face. He also painted some self-portraits in the tradition of *Dürer as Christ,* and numerous sorrowful religious subjects, including depictions of the Pietà or Deposition, which make him even more worthy of the term "neo-Gothic" than Schiele.

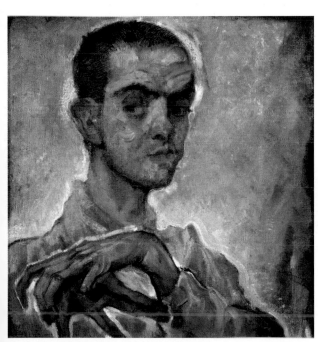

"Among the two chairs and several easels in my studio, a young man suddenly appeared. His dark eyes set in an ascetic, close-shaven head stared hard at me. Then he said: 'I would like to show you my paintings.' We left straight away. Opposite the Nordbahnhof, on the fifth floor of a grim-looking house, were some paintings leaning against boxes. The tubes were on the windowsill, and heaps of drawings were spread over the floor. The graphics were bizarre and very ornamental. I told him that I had a different conception of painting, but that I found the intensity he showed extraordinary and in some way related to my own. 'That's why I came to see you,' he said."
Max Oppenheimer, known as Mopp (1885–1954) *Memoirs*

Oppenheimer also related how, on their return from an unsuccessful attempt to sell some of their drawings, "he made the same contemptuous hand gesture and had the same look of suffering that I showed in the portrait I then painted of him" (left: *Portrait of Egon Schiele,* c. 1910).

Between Theosophy ...

Where Schiele's unusual treatment of bodies is concerned, it is certainly tempting to look for sources. At the beginning of the century, there were many attempts to replace the classical ballet by an art of movement capable of conveying the body's urges. One of these was made by Ruth Saint Denis, an American who had combined the fad for theosophy with some principles of Delsarte's expressive dance, which she had learned in the United States. It may well be that Schiele saw her perform when she came to Vienna in 1907, and was captivated by her routine.

Closer to home was his friend, the painter Erwin Osen, who with his partner, the dancer Moa, had created some little mime acts in a half-childlike, half-mechanical style inspired perhaps by the drawings that he himself

Planche XXXIV

CATALEPSIE
SUGGESTION : TERREUR

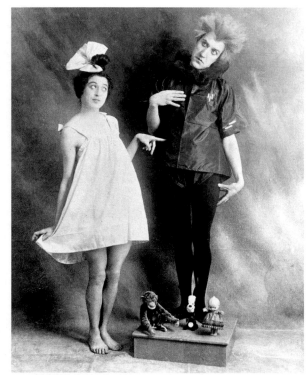

Did the strange body movements seen in Schiele's models have their source in pathology? At La Salpêtrière, the psychiatrist Jean Martin Charcot staged his patients in attitudes that were more "cultural" than "natural," notably borrowed from artistic imagery. It was difficult, even under hypnosis, to erase a patient's past, but it could be expressed by re-enacting emotional states, personal experiences, or borrowings from various registers of popular representation: religious images, illustrations from serialized novels, etc. (Above: "Catalepsy" in *A Photographic Iconography of the Salpêtrière* [J. M. Charcot's department], c. 1878.)

had done of the psychiatric patients at the Viennese Institute at Steinhof. Still in the field of pathology, it is possible that Schiele had access to the photographs taken at La Salpêtrière, the institution for the mentally ill, during the performances given by Professor Charcot's "hysterics."

Also of great importance were the occult spiritualist and theosophical groups of the period, which proposed a vision of the world inspired by the Orient, and offered their followers new explanations of paranormal phenomena and the great existential themes. At the same time Mondrian, Kandinsky, and Franz Kupka were finding encouragement for their move toward abstraction in the works of Madame Blavatsky and Rudolf Steiner, both of whom were well-known figures in the Theosophical Society.

The painter and set artist Erwin Osen had links with the world of theater, and he also did some acting in little sketches devised with his partner, the dancer Moa (opposite page, in a mime show; below, sketched naked by Schiele). Envied by Schiele's first biographer, who claimed he was a mythomaniac, Osen with his provocative gestures must have encouraged Schiele to rid himself of his inhibitions.

... Adoration and Terror

Whatever his influences, borrowings, and sources, Schiele's uniqueness remained in his treatment of form, and in an iconography whose complexity reached its peak in 1911, with compositions that were haunted by the sign of death. For some precise indication of their nature we may look to some written pieces, letters, and prose poems left to us by Schiele; the evidence they give us is fragmented and contradictory, but nevertheless two main themes emerge from them: a fervent admiration for and adoration of nature and life, coupled with appalling fear. What the critics sensed, Schiele's short poems

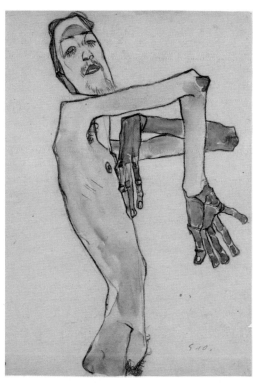

confessed; he was torn between an uncontrollable desire to merge into nature, and the fear of being swept away, of no longer being in control of the game. It was as if the painter was incapable of conveying this overabundance of life in which he was afraid of losing himself and by which he felt rejected, and therefore felt obliged to reduce it to precise, impoverished, mutilated forms: as if this life of primal urges had to be rejected, corseted, and controlled within a sort of straitjacket of plastic force.

The short autobiographical texts of 1910 do no more than express in polemical language the crises endured by Schiele, who oscillated between the Dionysian joy of complete immersion in nature and the terrors brought on by this confrontation with the urges. "Self-portrait: to dream forever, bursting with a superabundance of life—endlessly—with horrible pains inside the soul—blaze, burn, aspire to combat—spasm—consider—and crazily driven by a crazy desire—thinking is an impotent torture, it is futile to try to form thoughts. —Speak the language of the creator and give.—Demons!—break the violence—Your language—your sign—your strength."

The "Eternal Child" Turned Visionary

In 1911 Roessler, sickened by Schiele's gossiping, ingratitude, and boastfulness, sent the artist a stern letter, enjoining him to have a more "manly" attitude and not to indulge in bluff. Schiele was appalled, and answered by claiming for himself an eternal childhood, generous and unthinking, which would fertilize the living dead. "I, the eternal child . . . Living? Living is spurting out seed, spreading it, wasting it, and for whom? For other poor people no doubt, for the eternal schoolboy, oh the eternal schoolboy, oh the eternal uniform, oh the eternal State . . ."

It may, however, be from Schiele's correspondence with

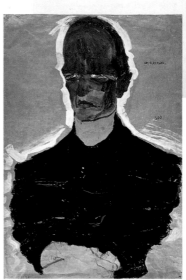

"The greatest experience of feeling is religion and art. Nature is the goal—but that is where God is, and I feel Him, strongly, very strongly, the most strongly."
Schiele, "Artist," 1910
(Top: poem above; bottom: *Portrait of Oskar Reichel,* 1910).

one of his main collectors, Dr. Reichel, that we learn more about the real nature of his convictions. Oskar Reichel had a large personal fortune, which did not prevent him from bargaining fiercely over even the smallest purchase, and treating Schiele with a certain sadism, to which the over-gifted child apparently did not object. As a doctor, he must also have been keenly aware of the debates at this time over the subconscious, sexuality, and occultism, and he was taking courses at the university taught by Max Dvořák and Josef Strygowski, who were art historians and also formidable critics of contemporary art. Schiele wrote to Reichel from Krumau about his feelings of disquiet, which as usual alternated with certainties in the vein of Rimbaud: "Sooner or later people will start to believe in my paintings and writings, and have faith in my words, which are rare but so very concentrated. Perhaps my paintings so far are nothing more than preludes, I can't tell; I am so dissatisfied with them, from first to last . . . I have become initiated and I have done my calculations, have observed one enigma after another and tried to apprehend it."

A more complex letter written in September once again began: "I have become a visionary." This was followed by a description of nature as a series of cycles of life and death, as the "spirit of origins" and the "great mother," and the assurance that Schiele was capable of defeating death. Schiele believed it was confirmed by the changes that took place in his body. "I see myself evaporating and exhaling more and more strongly, the vibrations of my astral light become more rapid, more immediate, more simple, like those of a great initiate of the world. That is why I give ever more of myself, . . . a fact which, despite myself, I have contemplated. . . . I am so rich that I must offer myself at all times." Behind the confusion in this outpouring, which

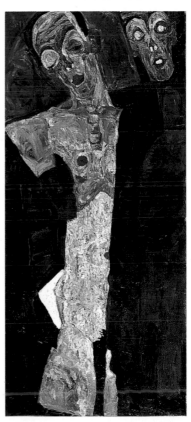

The allegorical compositions in which Schiele himself is a character are bordering on pathological (below: *Prophets [Double Self-Portrait]*, 1911). These are occult visions in which the artist, poet, and prophet seems to be confronted by a death that, in his other paintings, eats away at towns and engulfs mothers and girls in darkness.

has shades of Rimbaud's *Une Saison en enfer* (A season in hell) and frames the metaphors of sacrifice within an occult vocabulary, we sense a profound drama, which Schiele "despite himself had contemplated."

To Conjure Death

A shorter, more condensed prose poem from 1910 begins with a hymn of praise to the world and the sun, which is immediately followed by an evocation of the dead father. It is this death that Schiele would like to conjure by his art: "Look at me, Father, me, you who

Weighed down by the burden of revelation, the artist's head bends and rests on his shoulder, integrated into a composition of right-angled surfaces in which the hands, torso, and thighs are all interrelated. The body is listening to itself, hoping to be reunited with the world. (below: *The Poet [Self-portrait]*, 1911).

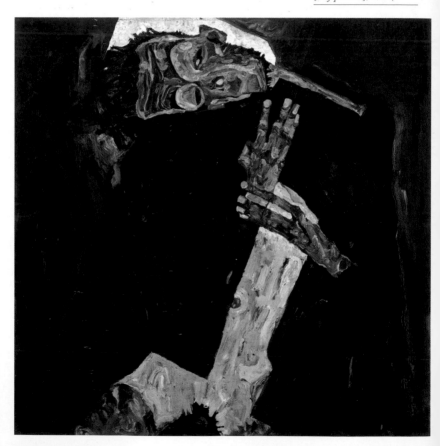

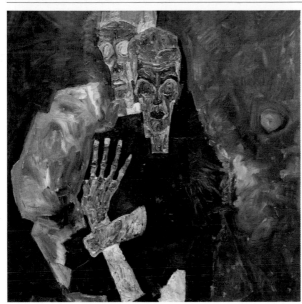

In Romantic literature, the encounter with the double is often a sign of imminent death. Anguished in the first version of this theme in 1910, and here rigid and impenetrable (left: *Self-seers II [Man and Death]*, 1911), the double tries to drag away the living person or reduce him to impotence, while an ectoplasmic face, seen in the brown area on the right, looks on indifferently. From the same period, *Delirium,* showing the painter being attacked in bed by an amorphous environment, recalls some of his nocturnal experiences. (Below: various studies and self-portraits, Notebook of 1911.)

are there even so, kiss me, give me the far and the near, climb and descend constantly, World. Now stretch out your noble bones, lend me a tender ear, your beautiful pale blue eyes. It really was like that, father, looking at you, I am." Danger and the forbidden were symbolized by the father who died of syphilis.

In the same period President Schreber (a famous case analyzed by Freud) rewrote the history of humanity in his *Memoirs of a Neuropath* to persuade himself to give way to his feminine urges; similarly Schiele tried to overcome his fear of forbidden fruit by rewriting the history of the world and intervening as a visionary, a chosen one destined to conquer death and sorrow. Every painting was a sort of conjuration of death by the meticulous, timid, analytical, fragmented reappropriation of bodies and of a nature that could not

be desired and loved "all of a sudden." Loving the flesh was not possible for someone obsessed by the bones of his father. Hence the feeling of being entrusted with a mission to redeem the world, in order once again to be in step with that world.

A little later, Schiele had a spiritualist experience; his father appeared at his bedside. "Last night I had a beautiful spiritualist experience, I was awake and yet in the grip of this spirit which had appeared to me in my dream. All the time he was speaking to me, I could not move or speak." In a letter to his friend Peschka, he admitted: "Even Gerti does not know the psychological suffering that I have to endure. I do not know if there is anyone in the world who remembers my noble father with the same melancholy as I do; I do not know if anyone understands why I search out those very places where my father was, where I can deliberately experience this pain for hours at a time. I believe in the immortality of all beings, I believe that a body is merely an ornament, I carry the memory, more or less confused, within me—Why do I paint graves and many similar things?—because all of that lives on deep inside me."

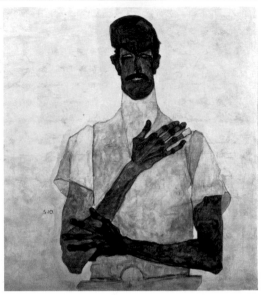

The gynecologist Dr. von Graff (above, 1910) had allowed Schiele to draw his patients in the consulting room or during their stay in his clinic, and also their newborn babies. A letter from Graff mentions a patient complaining of Schiele's infidelity, which suggests that the artist may have abandoned her when she was pregnant, or even having an abortion. This could explain the threatening posture and cold stare of the disquieting practitioner, who is pinned with clinical precision to the monochrome background of the painting.

To Die or Beget Oneself

It was not only the father who was involved; his misfortune extended to the whole family unit. There were two stillborn children, and a daughter who died at the age of ten. Schiele could have been among those who died. His ailing mother could also have died in childbirth while Egon remained alive. This terrible drama was the subject of the *Dead Mother* series of 1910–11, in which the puny

infant cries out not to be dragged into the death of the mother. It seems that Schiele also asked himself the question: what if I could give birth to myself? This bizarre theme of self-begetting appears in *The Birth of Genius* (1911), where the artist gives his mother his own face. It is highly possible that these obsessive fears were brought on by a personal event, such as childbirth and the abandonment of a baby, or an abortion that Schiele may have asked the gynecologist Erwin von Graff to perform. This would explain the monstrous portrait of the doctor in his white coat, with huge forearms and a killer's hands.

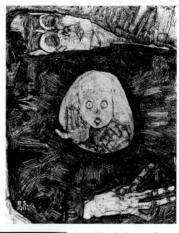

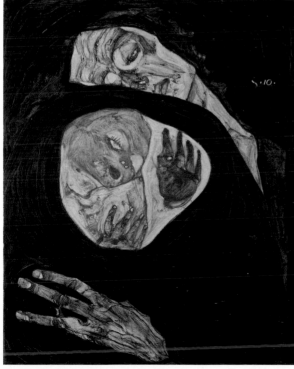

Why be born of a woman when one is a genius who communicates more easily with the other world than with this one? In a new version of the *Virgin and Child* (1910), Schiele contrasts the blessing being conferred by the child discovering the world with the cadaverous face of the mother trying to protect him (left: *Dead Mother I*). In 1911 the artist went so far as to give his own face to the mother, now deaf to the terror of the newborn, whom her own death appears to condemn (above: *The Birth of Genius [Dead Mother II]*, 1911). The following year he wrote to this woman for whom he felt very little love: "Am I not the finest fruit of your life? How great must be your joy at having given birth to me."

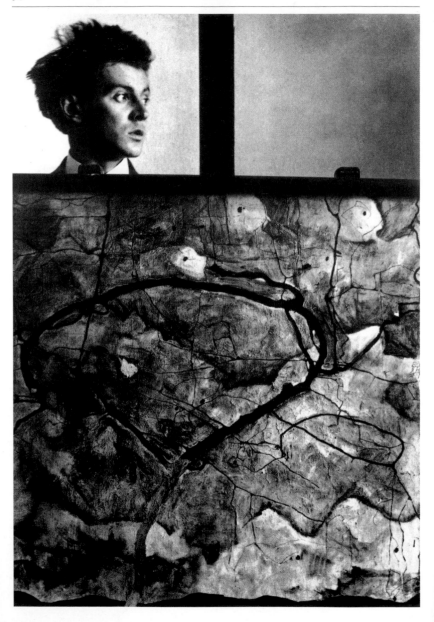

When Schiele moved to the country and took the permissive morals of the city with him, he clashed head-on with neighbors who were shocked to see him sketching naked young girls in the open air. One Lolita, fascinated by the twenty-two-year-old painter, ran away from home, and Schiele was accused of abducting her. Driven out of the lost paradise of childhood, the artist experimented in the confined space of prison with a brutal "rite of passage" into the adult world.

CHAPTER 3
FROM PARADISE TO PRISON

By posing with *Autumn Tree in Movement* (opposite page, at Neulengbach in 1912), Schiele confirmed the symbolic status of this work, which is also, in its way, a self-portrait. Right: *Two of My Handkerchiefs* (1912); while in prison, the artist made a virtue of necessity and transfigured his banal surroundings.

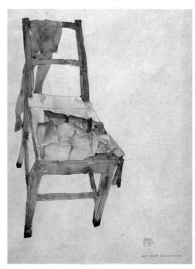

For Narcissus, anything can serve as a reflection of himself. Whether in a mirror or in water, he is always looking for himself, and he finds himself in nature or a new town. In May 1910 Schiele wrote to his friend Peschka: "Peschka! I would like to get away from Vienna, as soon as possible. Everything is so odious here. Everywhere there is envy and falsehood; former friends walk past me with sly looks. In Vienna there is nothing but shadow, the city is black, everything is shallow and clichéd. I want to be alone. I want to get back to the Bohemian forest. May, June, July, August, September, October; I want to see and work again, I want to see new things and I shall look for them. I want to taste the dark water and see the trees creaking in the wild wind, I want to look in astonishment at the decaying garden hedges, how all of that lives, and listen to the copses of young birch trees and their rustling leaves."

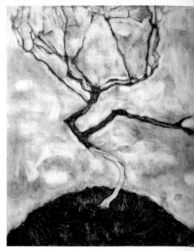

"All the Flowers Are Trying to See Me"

Nature was dark, but it was also friendly and supportive. Schiele did not go off into nature to lose himself in it; in a fantastical reversal of that situation, it was nature that came to visit Narcissus. "All the mosses are coming to mingle their rippling, caressing life with mine. All the flowers are trying to see me, and making my trembling senses resonate. Green oxide buds and delicate poisonous corollas uplift me. I float in space, indifferent . . . how strange the world is. Then, I dream of savage, tumultuous hunts, of red, pointed toadstools, of great black cubes that shrink and disappear then turn into giants, of fires with a hellish glow, of a battle between far-off, unknown stars, of eternal, gray eyes, of Titans struck down, of a thousand hands creasing up like faces, of boiling clouds of fire, of millions of eyes that look at me benevolently and grow whiter and whiter until I can hear."

Nature as portrayed by Schiele was precocious, sickly, and forced. His puny trees were young and defenseless, and had to be held up by supports, which gave the

Schiele's thin, sickly, malformed trees hang on to life only by the thread that attaches them to a support, and have difficulty in raising themselves off the ground (above: *The Little Tree at the End of Autumn*, 1911). Some of them resist the adverse winds and display a bizarrely twisted body with gnarled stumps. When the sky grows heavy, the air thickens into lead gray, cottony clouds negate the slightest hint of revolt. Is this a vision of desperation? The same sky can be found in *Hermits*, a double portrait of the artist and Gustav Klimt, where for Schiele the gray sky represents a funereal world.

paintings their only color apart from shades of sienna. Their branches were usually stripped partly or completely bare by fall or winter. If they reached adult age they showed signs of a bitter struggle with the elements. *The Little Tree at the End of Autumn* from 1911 has paid the price for its last few leaves by suffering amputations, which have been cauterized by touches of color. Its pathetically scoliotic frame stands out against a cottony white sky that clings to its branches.

This refusal to leave the earth and join the little amount of light and sun available, in other words to grow up, culminated in the second version of the

As an ultimate act of self-protection or renunciation, the tree creates an interior space that is as far from the ground as from the inaccessible sky (below: *Autumn Tree in Movement,* 1912). This is a narcissistic withdrawal, a cocoon in which the adolescent attempts to assert himself before he has his final metamorphosis.

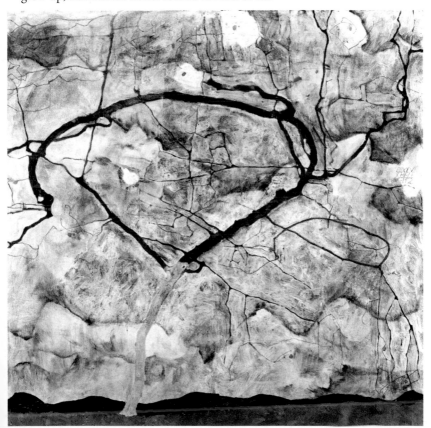

painting, where the tortured trunk turned in on itself, imprisoning a portion of the sky and leaving the numerous branches to spread out blindly. Although contemporary with Mondrian's schematized trees, this canvas is in no way an abstract reduction of a vegetal motif. Here we are faced with a fantastical vision of nature, where the relationships of proportion and scale are belied by the "antiphysical" posture of the vegetal subject. The landscapes themselves amount to very little; there are a few unevennesses in the terrain, shown just in outline: triangular hills, large stratified patches of color for the ground, simple geometric interplays between the earth, sky, and river. The dense sky is foliated with layers

In a letter written to Arthur Roessler on May 15, 1911, Schiele referred to "the high part of the dead city," and thus created a title for his future scenes of Krumau (opposite page). Marooned in the past and huddled under a menacing castle, the little town in Bohemia would prove an ill-fated choice of retreat for the artist (below, view of Krumau, c. 1910).

Das finsterwerdet ist die obere Burg die , über Zeit'

of cloud, sometimes lit up by a reddish sun.

Refuge in Krumau— the Black Town

In May 1910, Schiele realized his dream of solitude by moving to Krumau, a small town situated in a basin, on a wide bend of the River Moldau: an idyllic site from a distance, but not from close up. Like the towns that inspired Kafka's *The Castle,* Krumau is a huddled cluster of tall buildings and churches, dominated by a fortified castle: truly a forbidden city. Adalbert Stifter called it "the gray widow," and in *Brother and Sister,* Rilke portrayed a Krumau

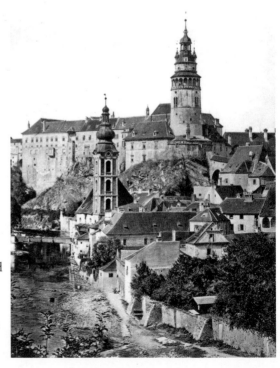

family trying to escape from its curses.

Egon thought of it as his mother's home town, but the refuge he hoped for turned into a trap. The family ghosts came and joined him, and it was then that his father appeared at his bedside. His views of Krumau, painted on

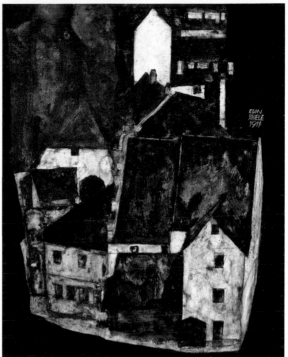

the spot, clearly reflect the blackness of a town even more maligned than Fernand Khnopff's *Bruges-la-Morte.* Schiele accentuates the meanders of the Moldau and reinforces the sense of enclosure in *Dead City III* and *City on the Blue River II,* where the terrified houses, seen from the castle, are imprisoned by a blue river that is turning black. As in the Expressionist films *The Golem* and *The Cabinet of Dr. Caligari,* the houses grimace and come to life. Like the houses in Dostoyevsky's *White Nights,* they start to speak and protest. The oblique façades of Krumau, with their anxious eyes at the top are in revolt. Down at water level, the porches seem to be disgorging their secretions into the river, while the damp that is eroding the plaster down to the brick draws disquieting silhouettes on the walls.

By exaggerating the bends in the Moldau and turning the blue water black, the artist makes the dead city an isolated, closed-off place whose lopsided, unstable houses groan and ooze out their fears and miasmas at water level, under the disquieting silhouette of the old Schwarzenberg Castle (above: *Dead City III,* 1911).

Willy, Wally, and the Rest

Osen and Peschka joined Schiele, as did Wally, a former model of Klimt's. The group did not go unnoticed: Osen

with his gangling figure and eccentric clothes, Egon in his white suit and black bowler hat, and Wally, a young girl with no family or chaperone. The youth of the town adopted them; they took part in an unsuccessful attempt to fly an airplane, and brought in the daughters of a coachman at Bellaria, a French-style garden on the perimeter of the castle's estate. They were also joined by Willy Lidl, a schoolboy from Linz whose parents had sent him to board in Krumau because they were worried about his poor progress at school. Two years younger than the painter, the young man fell under the spell of Egon, who allowed himself to be wooed. Osen introduced the group to Rimbaud, who became their idol.

When Schiele returned to Vienna under a white October sky, he wrote to Roessler: "Now I see the black town once more, it has remained the same, I can still see the same 'well-established people' as before—poor people—so poor, that the rapturous red of the fall foliage leaves them indifferent. Yet how well the fall suits that land of winter and wind." Willy did not hold out for a

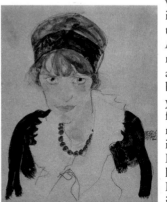

week: "Egon, everyone is in league against me, and they will crush me again. At school they have made the most horrible accusations against me because of you, and I love you endlessly, I live only for you. If you stay near me I will become strong, if you leave me I will die. Egon, I am tired. Do you love me? Reassure me, or I will go mad. My brain is on fire. Do not be hard

Above: Egon Schiele and his painter friend Anton Peschka, photographed in Krumau by Erwin Osen (1910). With his head bent over on his shoulder, Schiele is adopting one of his favorite poses; these would intrigue the town's inhabitants as much as those of his friend Osen, the "mime artist." The three of them, along with the model Wally Neuzil (left, drawing from 1912) and a cherubic boy called Willy, looked out of place amid the everyday folk in the small town of Krumau, who had little experience of eccentric behavior. They were particularly scandalized by the fact that the group included a young unmarried girl; meanwhile Egon, with his provocatively cut Viennese suits, did everything possible to draw attention to himself.

on me. I want to offer myself to you, just stay with me. Come quickly, you promised me you would."

"I Am Happy"

The following year Egon persevered, determined this time to move to Krumau for good. To escape from the miasmas of the dead town, he looked for a house on the outskirts, with a garden. Willy took care of everything. Eventually an eighteenth-century house was found; this was a *Gartenhaus* like the one where Goethe lived in Weimar. It was in a suburb, on a hillside overlooking the Moldau, with several terraces where one can imagine enclosed gardens full of flowers. Schiele arrived on May 13. For the first time in his life, the artist felt independent. Far from the intrigues and jealousies of Vienna, he believed that happiness was possible. Bursting with hope, he forgot about the failure of his first personal exhibition at the Miethke Gallery, and put his faith in Krumau.

The devotion of Willy and Wally made his life easy, and his "garden house" was a paradise on earth. He

With the efficient cooperation of his friend Willy, Egon set up a little retreat in an old garden house on the edge of the town, on a bank of the Moldau, which looked as if it was out in the country. Carefully restored and freshly repainted, the house overlooked shady terraces full of flowerbeds. A succession of friends came to visit, and children posed in the garden, sometimes in the nude, which greatly shocked the neighbors (below: *Field of Flowers,* 1910).

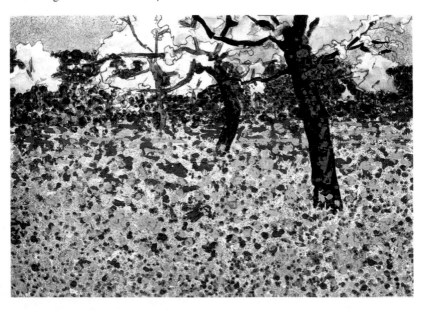

immediately sent out invitations: "Dear Doctor Reichel, I will tell you everything about my magnificent country house and my garden full of flowers. I am happy, I am happy." The faithful Peschka was sent a poem: "The old houses are heated by the sienna air, everywhere there are rolls turned brown by the sun. White-red and on it an old barrel-organ, slowly playing—the large all-year coat of the blind musician is an old greeny-brown color, holey and torn. I am writing to show you everything that has been granted to me, here children's eyes, large and small, are laughing, they are talking about me out loud. Up in the garden everything is green, there are flowers that look like humans and flowers." A letter to Roessler was written in the same tone: "The children call me the Lord God painter because I walk around in my painter's smock in the garden; I draw different children and old women, leathery faces, I wander around and sit around, everything here is more agreeable."

An Atmosphere of Scandal

This delightful evocation of springtime had shades of the scene in Murnau's film of Goethe's *Faust,* where Margareta dances a circle dance in the walled garden with the village children; nevertheless the "hostile forces" were already at work. At this time, to live with a woman like Wally—who was seventeen—without being married was a grave social error. The "improper arrangement" did not go unnoticed; nor did the idyll with Willy, whose parents cut off his allowance, demanded that he be expelled from school and sent back to Linz, and wrote to Schiele, who naively tried to persuade the teachers to go back on their decision.

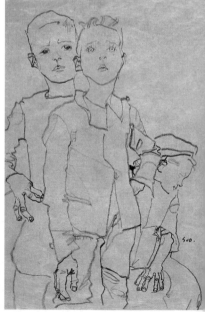

As Schiele's account indicated with childlike joy, the garden house was open to all. He asked children to pose for him, and whereas in the city this would have remained hidden by anonymity, here it caused a scandal. One child agreed to pose, and then brought along others. Drawings were left lying around, the children talked and the parents gossiped, and rumors spread like wildfire. When Schiele sketched a girl called Liesl Woitsch naked in the terraced garden, he was caught in the act by a neighbor, and the owner of the house was instructed to bring an end to what had become a public scandal. On July 31 Schiele wrote to Roessler: "You know how contented I feel in Krumau, and now my life is being made impossible. We are being shunned just because we are "reds." I could of course defend myself, even against 7,000 people, but I have no time to waste, and what is the point?"

Visionary or Voyeur?

Was Schiele just playing innocent games, or were they forbidden ones? After this first warning, would the "eternal child" who liked playing God behave more sensibly? His work from this time showed a malaise that could not be resolved by pretense, and beneath his universal love lay an ill-concealed fear of happiness.

If his nudes were ambiguous, his "erotic" paintings were disquietingly cold. One can only imagine what Frau Benesch, who found his early nudes "unfeminine," would have thought of those that her husband did not dare to acquire.

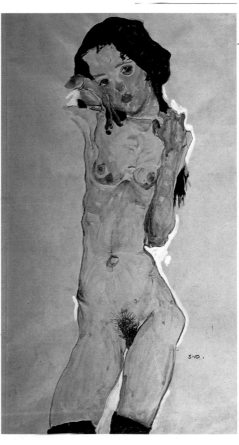

Childhood enabled Schiele to dwell on the sexual ambiguity that haunted him (opposite page, and below: *Nude Girl with Black Hair*, 1910). But what was possible in the big city was a scandal in a provincial community. The children told their parents, and the voyeuristic neighbors sounded the alarm.

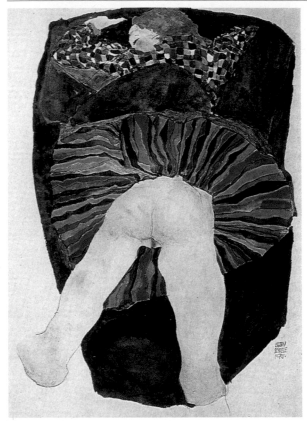

Precocious, sickly, gauche, or provocative, little girls from the streets offered the artist their fragile anatomies. The whole composition of *Semi-Nude* (left, 1911) is based around the vagina, a thin pink or sometimes shaded mark, which radiates its intimacy here in the context of the thrown-back skirt.

Turned in on itself, female sexuality seemed less frightening to Schiele, who portrayed his girls in love with tenderness (opposite page, *Two Girls [Pair of Lovers]*, 1911). With their eyes closed, and isolated from the world by a black blanket painted over a void, they are unaware of

But where did the nude end and the "erotic" begin? At what point did the visionary become a voyeur? It was already possible to interpret the most convulsive poses in the self-portraits as portrayals of orgasm, showing tensed, rigid, catatonic bodies, with guilty, cut-off hands, and narrowed eyes expressive of sexual fantasy and the agonies of climax. Masturbation would also explain the appearance of the "double," a single manipulator who was solely responsible.

This practice might not lead to deafness, but as shown in the complicit mirror, the pleasure of seeing—known in Freudian theory as *Schaulust*—was too great not to

the male voyeur for whom nevertheless the painting appears to be intended. Schiele often used this high-angle viewpoint, which made the world unreal and the voyeur ultra-powerful, for erotic nudes but also for portraits and his occasional views of interiors.

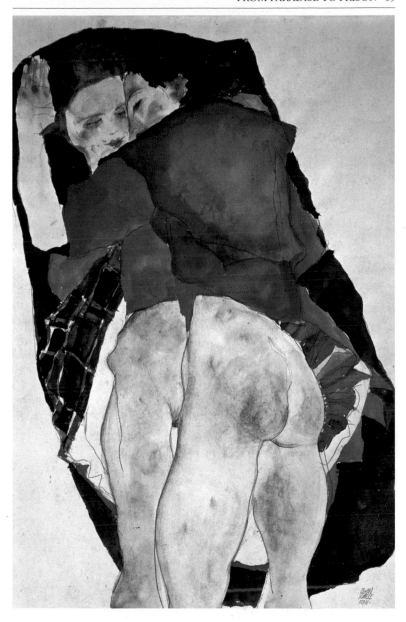

blind the voyeur. Hence the empty eye sockets in those masklike faces that refuse to see.

For us today those nudes, which were judged obscene at the time, have the crudeness of vivisection. "It is not fun to pose for him," said one of his models, "he is only thinking of one thing." The torsos, isolated from the paper by a white surround or a multicolored Wiener Werkstätte blanket, focus attention on the essential. The black stockings, sometimes decorated with a red ribbon, reinforce this appearance of truncated sexuality. The low-angle perspective is used daringly; the eye is first trapped into looking at the huge expanse of thrown-back skirt, then rushes to the other side of these inexpensive frills and stumbles upon the vagina, a red slit which is highlighted by two patches of white gouache. This nineteenth-century style of composition, showing the intimate jewel as set in surrounding corollas of fabric, was accentuated by the artist in *Observed in a Dream* (*Die Traum-Beschaute*), where the reclining girl's hands are holding her labia open to the mirror's gaze. Such extreme precautions suggest that the artist was very fearful; he did raise his guard, however, when painting lesbian couples, who were allowed to withdraw into themselves and escape his inquisition. Even so, their

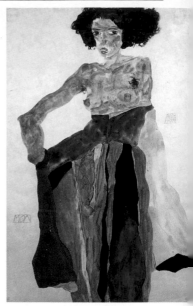

Erwin Osen's partner in his little mime acts was the dancer Moa, who was of Polynesian origin and was often drawn by Schiele in choreographic, acrobatic, and erotic poses (above: drawing from 1911). The dancer's professional nonchalance enabled the artist to give himself over without reserve to the pleasure of drawing.

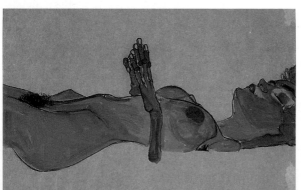

Probably drawn in Dr. Erwin von Graff's clinic, *Dead Young Woman* (left, 1910) is an experiment with the other pole of existence, so close to the artist's heart.

happiness seems threatened; the rug on which the two girls are lying is isolated in space and looks rather like a small boat, or even a coffin.

Were the Models Too Young?

Were the models women, girls, or little girls? This became an important question when the law began to take an interest in these bundles of papers. The borders were blurred, however, at a time when the age of sexual majority was fourteen, and child prostitution was therefore legal. We can still see evidence today of the difficulty this has caused in catalogues raisonnés of Schiele's works, which arrange the nudes according to their apparent age. The same double moral standard that afflicted the Schiele family led to a huge *danse macabre* in all sections of society, which is very well described in Arthur Schnitzler's *The Round Dance*. The poet and aging womanizer Peter Altenberg remarked that a woman could never be young enough, which suggests that Lolitas and their substitutes still had the aura of a perversion that need not be branded as evil. In his hotel room was a gallery of beauties on visiting-card photos, where friends' children mingled hazily with fake child cabaret performers. Osen's dance partner, Moa, struck childlike attitudes that perhaps enabled Schiele to feel

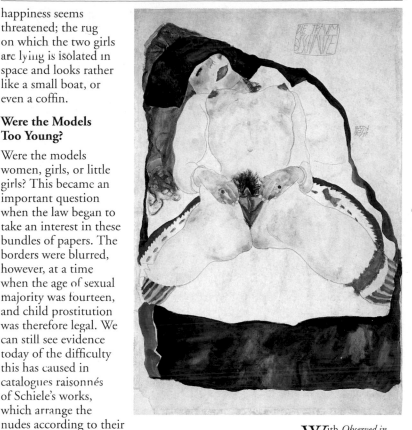

With *Observed in a Dream* (1911), Schiele's voyeurism became clinical. The clothes are pulled apart with the same surgical precision as the sexual organ, which is kept open by the model's complicit hands; she is more "absent" in her docile obedience to the painter's instructions than truly dreamlike, as the title would have us believe.

confident with her; her "naughty little girl" type of femininity is the only one that appears to have given him pleasure in his work of 1911.

The Neulengbach Affair

Almost as soon as Schiele had returned to his mother's home in Vienna, he had only one desire: to find another country retreat. This time he set his heart on Neulengbach, a small town that was half an hour by train from Vienna, and where his Uncle Leo rented a holiday home. The refuge was quickly found; it was half of a house, on the ground floor, overlooking the countryside on the outskirts of the village. The Krumau lifestyle was resumed, as was the gossip: "Our children are posing for a painter who lives in sin with a young woman."

This time the scandal was not caused by a posing session in the garden, but by a girl called Titiana who ran away from home and landed one evening during a thunderstorm on Egon and Wally's doorstep. They were embarrassed, and did not have the courage to send her home. The next day they took her to Vienna, but she did not dare go to her grandmother's house as she had

"And as fate would have it, a little girl who loved my company had arranged to come to my house alone. I sent her away, but she came back the following evening and would not go away again. . . . So I left her in the house and sent a note to her parents. Her father came to fetch her, she was checked to see that she had not been touched, and yet the affair ended up in court. It was then that I was humiliated in a shameful fashion because of my kindness. I completely lost confidence in most of my friends. Only Wally . . . behaved so nobly that I was overcome by it."
Schiele to Franz Hauer
January 25, 1914

promised, and so spent another night away from home, in a hotel with Wally. She then went back to Neulengbach and spent a third night in the "improper household." The following day her father, Herr von Motzig, who was a former naval officer, came to fetch his daughter and on the way lodged a complaint against the couple for abduction. The complaint was not withdrawn, and led to an investigation. Two policemen came to the artist's house and confiscated a nude, which was pinned to the bedroom wall and was judged to be compromising. At the same time they removed some 125 other works that Schiele naively admitted were in a cardboard box.

On April 13, Wally, Egon, and their little maid were summoned to the police station, where the artist was interrogated for an hour and a half, then remanded in custody. At the beginning of May he was transferred to the prison at Sankt Polten to be tried on three charges: abduction of a minor, incitement to debauchery in the case of another minor, and violations of decency and morality. On May 17, he was sentenced in the presence of a jury of four. The charge of abduction was dropped, as was that for incitement of a minor to debauchery. There remained the unfortunate watercolor on the wall of a room to which children had access. For this he was sentenced to three days' imprisonment, which his time in custody did not cancel out.

Despite the horrors of prison, it could be said that Egon got off very lightly. Not only was his version of

The court and prison at Neulengbach (opposite page).

Eros, a sad, gray self-portrait of Schiele, who devoted several of his drawings to masturbation. At a time when autoeroticism was stigmatized as causing a slow degradation of the body, this Priapus-like phallus seems to embarrass the artist more than lead him off on paths of the imagination or erotic fiction.

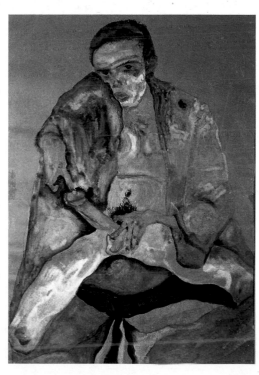

the journey to Vienna accepted, but also the testimony of the second child witness, whose identity he did not know, was altered during the hearing. The third charge alone could have led to six months' imprisonment.

Schiele, a "Tormented Artist"

The Neulengbach affair did more for Schiele's reputation than his work itself. This was partly thanks to Roessler, who, having been absent from the event, must have felt guilty that he had been unable to do anything for his protégé. A few years after the artist's death, he published a supposed prison diary he had written, based on conversations he had had with Egon, interpretations of drawings done in prison, and fragments of writing.

"The passage of time and the death of the artist have created a sufficient distance for Schiele's imprisonment to appear now as what it was from the start: a tragic blunder by an over-zealous moral police, and the grievous martyrdom of an artist who was misunderstood in his time."

Apart from Schiele's version of the circumstances of the "abduction," the diary dwelt on the traditional themes of the "tormented artist," driven to despair by his bewilderment over a pointless incarceration, abandoned by all his friends, wounded that his work should have been judged to be pornographic, and in particular sickened by the

Schiele the prisoner was obliged to clean with brooms and rags (below: the corridor the Neulengbach prison, 1912). His comment on this humiliation memory was a stoical phrase written in capital letters (opposite page, below): "I do not feel punished, but purified!" (opposite page, above: *For Art and for Those Whom I Love, I Shall Endure My Sufferings Happily until the End,* 1912).

judge's "auto-da-fé": "At the hearing, one of the works that had been confiscated from me was solemnly burned in a candleflame by the judge himself in his robes!" To this extract from a letter, Roessler added a rather overblown finishing touch: "Auto-da-fé! Savonarola! Abominable castration—you may as well go into museums and destroy all the best works of art. Those who deny sex are unclean. They despicably sully their own parents who gave them life. Those who have not suffered as I have should be ashamed when they see me."

Artistic or Pornographic?

Although Schiele may have found his time in custody abusive, he knew very well

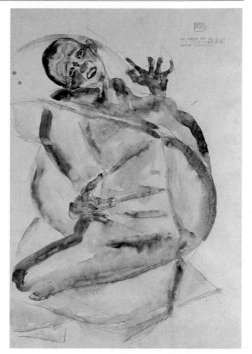

NICHT GESTRAFT SONDERN GEREINIGT FÜHL ICH MICH!

what he was being accused of. As well as that, far from being abandoned, he had been supported by his collectors—Benesch had visited him in prison, and Reininghausen had sent him an excellent lawyer through Peschka, and paid a retaining fee—and Egon's mother and Wally were allowed to see him. Schiele himself described some of his drawings as "erotic"; these were intended very specifically for art lovers such as Reininghausen, and the artist planned to put the most "significant" ones together in a portfolio.

There had in fact been no question at any time of judging whether his work was artistic or pornographic; the real concern had been to know whether minors could

"I now have materials for painting and writing again, thank heaven; . . . I can keep busy, and that will help me to endure what otherwise would have been unendurable. For this to happen I went down on bended knee, I belittled myself; I begged, pleaded, and would have burst into tears if necessary. Oh my art! What would I not do for your sake?**"**
Egon Schiele, 1912

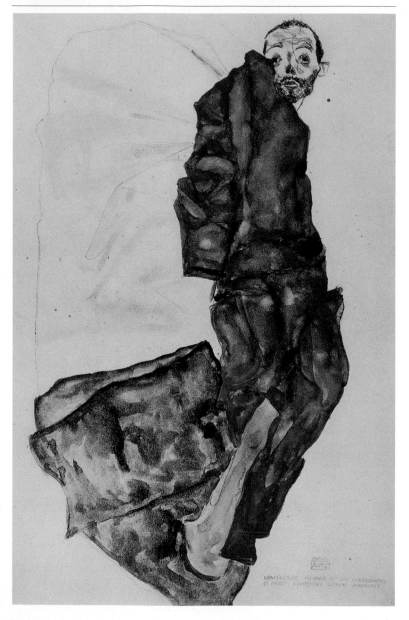

have had access to it. As for the auto-da-fé, it is impossible to verify whether this actually happened, since the archives of the Sankt Polten tribunal were subsequently destroyed by occupying Russian troops. Such a procedure was entirely alien to Austrian law, however, and may have been a fanciful invention of Schiele's, since there was no report of it elsewhere. An original work could not in itself constitute an offense unless it became public by being exhibited or reproduced.

That having been said—not to minimize the horrors of the prison sentence, but to remove from the Neulengbach affair the misleading romantic gloss that has been attached to it—Schiele's loved ones were in fact quite worried about the risk it posed to his mental health, bearing in mind the "spiritualist" episodes that had occurred in Krumau. At one point they even considered pleading diminished responsibility. It is also clear that, even if Schiele's behavior with the Neulengbach children was irreproachable, he should never have asked them to pose for him without seeking their parents' permission, as some of his friends advised him to do. What is more, Schiele never concealed the feelings he had for some of the *Mädchen,* be they slender women or precocious little girls.

The most famous portrait of Poldi Lodzinsky, in which her hands are positioned so as to simulate a vagina, suggests that he had a close relationship with her, or at least wanted to have one. There is more evidence of this in a prose poem of 1910: "Portrait of the pale, silent young girl: a pollution of my love—yes, I loved everything. The girl came along, I discovered her face, her subconscious, her working girl's hands, I loved everything about her. I had to paint her, because she was looking at me and was so close to me.—Now she has gone. Now I have nothing left but her body."

"To Prevent an Artist from Working Is a Crime"

From his time in prison, Schiele left us some pictorial evidence accompanied by commentaries. First there were self-portraits that add to the vision of the suffering artist. The body is stretched out or huddled up in an old coat

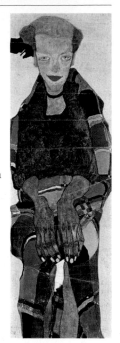

The widthwise *To Prevent an Artist from Working Is a Crime, It Is to Kill Life Which Is in Gestation* (opposite, 1912) is signed vertically, so when the title is read, the figure of the suffering artist floats like a ghost, solemnly informing the viewer of the injustice he is being subjected to.

Schiele's efforts to stylize the model in *Portrait of Poldi Lodzinsky* (1910; above) were not enough to win over the Wiener Werkstätte, for whom this work was intended.

or under a rough, dirty brown blanket, and from this shapeless cover emerges a head with close-cropped hair and three days' worth of unshaven beard. Today it is impossible to look at the painter's emaciated face and hollow eye sockets without being reminded of photographs of the horrors discovered in concentration camps.

Some of these portraits of Schiele lying down were turned sharply to the vertical position by the direction of his signature, and this gave the images an added sense of being apparitions; standing, or rather floating in an unknown space, the specter was rising. Next to the signature were handwritten captions or maxims such as "Prisoner" or "To prevent an artist from working is a crime, it is to kill life that is already in gestation." Schiele was clearly not averse to adopting the posture of the condemned man: "I love contrasts."

The Lyricism of the Almost Nothing

Imprisonment forced the artist to make do with what he had around him: the color of the cells, with brooms and cleaning-bowls stored in the corner—"I do not feel punished, but purified!"—or alternatively "The door to the outside!" which was a plain wooden door with a barred window above it, looking out into the countryside. At a second glance we see the birds that

One of the drawings executed by Schiele in the Neulengbach prison, *The Door to the Outside.* The meticulous rendering of the implacable iron lock contrasts with the whiteness of the door, and with what can be seen of nature outside, which although fragile is a symbol of hope. Nothing is too humble for the artist, who transforms triviality.

Brother Egon loved, calling out to the spring from a few branches which are very thin in contrast to the knotty thickness of the bars. This lyricism of the "almost nothing" made objects sing, including very humble ones such as an orange, which was "the only light" in the gray cell. A wooden chair took on the dignity of a sculpture, a minimal structure with some patches of color hanging from it: "Two of my handkerchiefs." Egon had always loved the simplicity

Schiele's *The Only Light Was an Orange* (1912) alludes to the happy shores and sunny landscapes "beyond the Alps," the orange lights up the gray universe of the prison with its modest splash of color.

of old furniture, and sang on an empty sheet of "the organic movement of the seat and the pitcher." Two other chairs and the three feet of a stove celebrated the power of art to transfigure the insignificant: "Art cannot be modern, it is eternal."

The dismal daily round of the prisoners at Sankt Polten was a far cry from the "flower-studded" enclosed garden where Schiele, like Margareta in Murnau's *Faust,* had played with a ring of dancing children. But perhaps in the town of Krumau, as in the medieval town in *Faust,* the devious shadow of Mephisto had arisen without his being aware of it.

"I have just painted the place where I sleep. In the middle of the filthy gray of the blankets, a glowing orange which V. [Wally] brought me, the only emanation of light in this space. This little patch of color gives me an indescribable sense of well-being."

**Egon Schiele
April 19, 1912**

In the three years leading up to World War I, Schiele developed his career as a painter. Based on the themes of his visionary canvases, he dreamed up large allegorical compositions intended to revive the social role of painting. The idea was a failure. His urban landscapes became softer and more colorful. He also returned to portrait painting, reconciling the requirements of the commission with his need for spiritual intensity.

CHAPTER 4
RESURRECTION

Schiele's sorrowful period culminated in this image of Saint Sebastian offered up to the arrows of the critics (opposite page: poster design for an exhibition at the Arnot Gallery, 1915). *In The Artist's Bedroom in Neulengbach* (1912)—a distant, popular echo of the Viennese style—the room is seen from above, as if a spirit had come to visit this tasteful and perfectly ordered retreat.

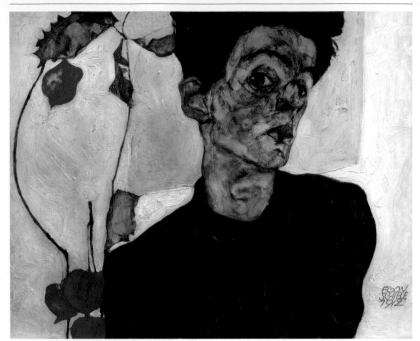

The Neulengbach affair completely disrupted a life that was finally striving toward happiness. After the period of exile in Krumau, the relationship between Schiele and Valerie Neuzil (Wally) had grown stronger. She had gone from being his model to becoming his companion and lover, who did everything possible to smooth out the difficulties of their life together. When Schiele was imprisoned she behaved perfectly, even managing to win over Marie Schiele. The little house at Neulengbach could be a "little paradise" just as much as the house at Krumau, and it was during the calm before the storm that Schiele painted one of his very few interior scenes. We know that he was extremely particular about furniture, preferably painted black, and that he had a liking for some of the Wiener Werkstätte colored fabrics and a weakness for toys and popular or exotic objects. There were not many of these, just some talismans he liked to collect.

Even if he had seen van Gogh's famous *Bedroom at Arles,* which had been exhibited in Vienna and

Like Wassily Kandinsky and Gabriele Münter at Murnau in Bavaria, who painted their furniture in clear, local colors, and took their inspiration from popular paintings, Schiele simplified his palette for this *Self-portrait with Chinese Lantern Fruit* (above) showing him with his favorite plant, the physalis, and also for *Portrait of Valerie Neuzil,* his companion Wally (opposite page, 1912).

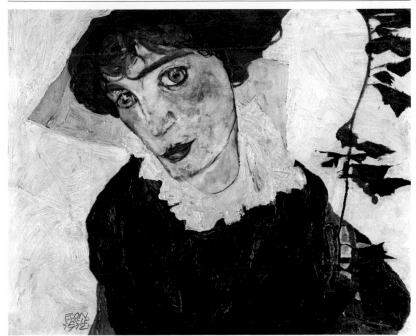

was owned by Oskar Reichel, the little bedroom in Neulengbach had nothing in common with it apart from the fact that its furniture included a bed, a bedside table, and a chair. The elevated, unreal viewpoint changed the scene entirely and enabled the artist to play with perspective and juxtapose objects and furniture as areas of color at different levels. The crossed stripes on the bedcover, a mark on the pillow, and the patches of color on the pottery all help to pin down these surfaces, which otherwise would have a tendency to slide over one another. In the foreground we see a family chair, now painted black but still with its plush red upholstery. On the right is the swing mirror that would provide so many self-portraits and indiscreet reflections.

Between Happiness and Anxiety

From the same period, a double portrait of Egon and Wally carried on with harmonies of black, red, white, and green, like those on naïve Biedermeier glass paintings.

The daughter of a schoolteacher and a former model of Gustav Klimt's, Valerie Neuzil, known as Wally, was Schiele's faithful companion from 1911 to 1915. The artist called her his *Zwitscherlerche,* "my warbling lark"; Roessler described her to the painter as "your shadow"; and Osen referred to her as "Mrs. Schiele." The Neulengbach ordeal strengthened their relationship, but later on Schiele would be unable to resist the idea of a "good" marriage with another woman.

The portraits were conceived as a pair; one is signed on the right, the other on the left, and the flowers are symmetrically matched. Egon looks down on us with hauteur, while Wally gazes trustingly at us from lower down. Both faces are fixed at the center of the composition by geometrical shapes that contain them. The lovers are both dressed in black, and Wally also wears a frilled white collar. They could be mistaken for two young married country folk. In the midst of their happiness, however, there were still elements of anxiety. In *Self-portrait with Black Vase and Spread Fingers,* painted around the same time, a shadowy face taken from a popular piece of pottery is hidden under camouflage among the harmonies of color, reminding us of the artist's contrasted vision of the world.

Melanie and Gertrud Schiele—the tall, imposing sister and the small, mischievous one—posing here c. 1911.

"How Great Must Be Your Joy at Having Given Birth to Me"

When he came out of prison, Schiele did not feel able to impose himself on the hostile population of Neulengbach. At first he returned to his mother's home in Vienna, then

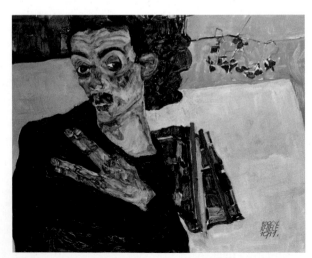

In this new self-portrait (left) Schiele used a kind of pictorial trick that is characteristic of mannerist painting; he incorporated a black, possibly South American piece of pottery, placing it like a shadow against his head. Invisible at first glance, its outline suddenly comes into view, like the "dark side" that each of us tries in vain to hide. Its intrusion is especially brutal given that on this occasion the artist had opted for a soft, agreeable "manner," in the spirit of the two portraits on the previous double page.

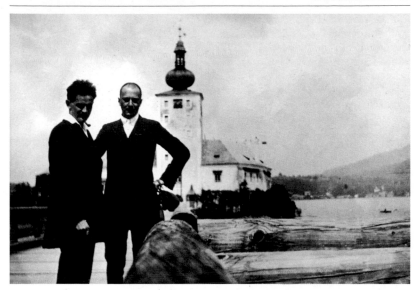

started to look for a new studio. For a while he considered taking over Osen's, then in the fall found himself one in Hietzing, not far from the forests and the countryside. His relationship with his mother did not improve. In a letter about family problems—Gerti wanted to become engaged to Peschka, Melanie was living with a woman, his mother was being illogical—we see an exalted outburst from the young "head of the family": "You are of an age when I think that the human being feels the need to consider the world with a pure soul, without reserve and without constraint, and to look at the fruits that have come to maturity, are already autonomous, and have put down roots of their own. This is the moment of great independence. Without any doubt I am becoming the greatest, the finest, the rarest, purest, and most accomplished of fruits, in me the most beautiful, noble and manly of qualities are united by my own will—I am becoming the fruit that will leave behind eternal living beings even after its decay; how great then must be your joy at having given birth to me?"

Here we see the artist's revolt against his family, but also an almost Christlike sense of the genius as opposed

Egon Schiele and Arthur Roessler in front of Orth Castle at Gmünden, between Salzburg and Linz, no doubt photographed by Wally while the couple were staying with the critic during the summer of 1913.

"During his stay at Altmünster, Schiele was delighted by the exceptionally good weather, since he so longed for southern sunshine. We often went rowing on the lake, and made several visits to Orth Caste. At no time did Schiele think of painting, he gave himself over entirely to a vegetative existence, which for him was a rare state of mind."
Arthur Roessler

to his earthly mother, the creator claiming his status as a spiritual progenitor. Not that he disdained his family; on the contrary, he still had a great affection for Gerti, which partly explains his jealousy with regard to Peschka, and in the summer of 1912, after staying with Wally at Roessler's house for the month of July, arranged at his own expense to spend the whole of August with his mother and sisters at Sattendorf on the Ossiachersee.

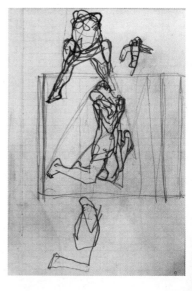

IX. KOLLEKTIV-AUSSTELLUNG
NEUE KUNST
HANS GOLTZ
MÜNCHEN / ODEONSPLATZ Nr. 1

EGON SCHIELE / WIEN

SCHIELE: „LIEBKOSUNG"

VOM 25. JUNI BIS 12. JULI 1913

Cardinal and Nun, an Allegory about Sexuality

In the early days after Neulengbach, Schiele had difficulty recovering from the shock of the experience. The symbolic sentence to three days of being shut in a tomb and descending to hell reinforced his conviction that he was a martyr. Seeing himself as a victim of the iniquities of the age, he went through a period of revolt. His self-portraits at this time showed a man flayed alive, a body suffering and rebelling. The brow was lowered, ready for the attack. In the case of *Cardinal and Nun* (1912), the attack was twofold. Returning to Klimt's now canonical *Kiss,* Schiele criticized the millstone of morality that was weighing down on staunchly Catholic Austria. The red and black couple preparing to commit the sin of the flesh was in the tradition of Lutheran satires on Rome the harlot.

The painting was accepted by the Munich Secession, but rejected by the exhibition at the Hagenbund in Vienna. Convinced that he had the possibility of communion with the Spirit of the World, the artist felt nothing but disdain for any official agency. His anti-papist mockery was accompanied by a visionary violence

With ten works, seven of which were reproduced in a catalogue with *Cardinal and Nun* on the cover, Schiele took pride of place in June–July 1913 at the Goltz Gallery in Munich (left, catalogue cover), and in August showed another landscape there. Despite being somewhat akin to the aesthetic of the Munich-based Blue Rider group (Der Blaue Reiter)—Schiele had bought the first issue of their review of the same name the year before—his work was not well received. Below: preparatory sketches for *Cardinal and Nun,* a number of which have survived.

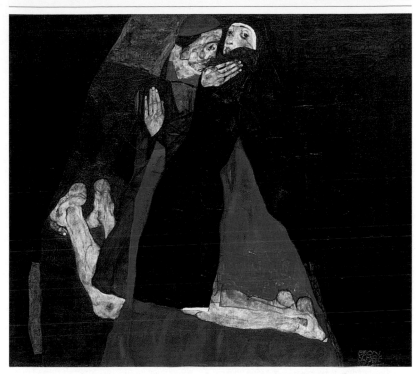

that he occasionally tried with difficulty to explain. "It may be a poet, an artist, a scholar, or a spiritualist," he told the owner of *Revelation* (1911) in reference to the "great personality" giving out an hypnotic "astral orange light," into which a kneeling adolescent in the foreground was sinking. The fact that Schiele rarely made statements of this kind clearly indicates that there was no system behind his thought. He seems to us to have been searching in his memory for the origin and gestation of compositions that had matured in a semi-dreamlike state.

"Like a Cloud of Dust on This Earth"

The interpretation of apparently "simpler" paintings such as *Hermits*—an allegorical portrait of the artist and Klimt—is in fact just as problematical. Ever since the two men had met in 1909, Klimt had become Schiele's

In his preface to the Goltz Gallery catalogue of 1913, Arthur Roessler played devil's advocate and alluded to the public's reluctance to accept Schiele's work: "Why does Schiele only paint what he likes, and not what is saleable? One has to admit it; his paintings have nothing of that clean execution and naturalism which are so popular, there is no moral tendency in them, nothing agreeable, on the contrary they are highly irrational and serve no useful purpose."

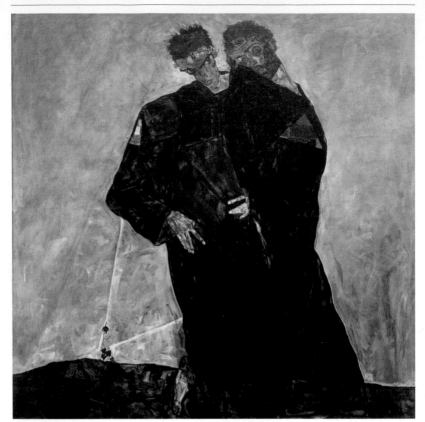

surrogate father. The attraction that Egon felt for
him was based on the feeling of a common destiny,
symbolized here by the equivocal interpenetration of
the figures—Are they standing or kneeling? Which one
is in front of the other?—and the fact that they are each
wearing a monk's robe, the sign of artistic brotherhood.
The older man, crowned with red roses and with his
eyes closed, seems to be leaning on the disciple's
shoulder, while the disciple, with his crown of white
roses and rebellious glare, is dragging him forward.
Schiele explained this to one of his collectors in February
1911: "I would like to say something about the sequence
of ideas in this painting, which may perhaps explain

A complex symbol of
Schiele's relationship
with Klimt, *Hermits*
(above and opposite
page, detail) is a return
to the romantic vision
of the artist's role as an
intermediary with the
absolute, a member of
a sacred brotherhood
which can help humanity
on its journey toward
mystery.

everything, not only for me but for the spectator. It is not just a gray sky but a funereal world in which the two bodies are moving, they grew up in it alone, they have grown organically from the soil itself; all of this universe must, like the figures themselves, represent the fragility of everything that has any importance; . . . the indecisiveness of the two figures, which are seen as turned in on themselves, is entirely accurate, these are the bodies of people who are tired of life, suicides, but in any case human beings who are nothing but sensibility. These two figures must be seen as a cloud of dust on this earth, a cloud that wants to take form but is condemned to collapse, powerless." The two flowers, one still upright on its stem, the other already on the ground, are an echo of this futility.

Usually dressed in tunics or shirts, the allegorical figures of 1912 and 1913 suggest a sort of sacred choreography in which every gesture and color is significant. In a number of these works we recognize the artist, who regarded himself as one of the leading actors in this new symbolism of body movement.

The metaphor of the cloud is curious, since the two figures stand out clearly in a triangular composition against the gray background. It may be, however, that we should give equal importance to the white lines and gradations of color that put life into this cottony dullness, and form a kind of halo around the couple. The halo was a recurrent theme in Schiele's work, from the pink cloud in which Roessler seemed to be meditating, to the bent-over figure in *Poet* and those in the *Dead Mothers, Pregnant Woman and Death,* and *Revelation,* all of which were painted in 1911.

The most compartmentalized of these compositions, such as *Agony* and even *Cardinal and Nun,* show the protagonists placed inside an irregular shape that stretches up toward the top of the canvas, and either breaks up or bends before it reaches it. The same motif is found in *Autumn Tree* (1912), where the tree turns in

(Following double pages: page 86, *Preacher,* 1912; page 87, *Homage to Gustav Klimt;* page 88, *Fighter,* 1913; and page 89, *The Truth Was Revealed,* 1913.) The crucial inspiration for this search for the monumental came from the large figures painted by Ferdinand Hodler.

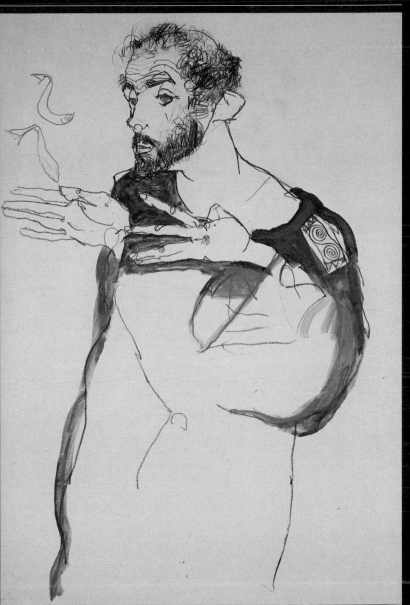

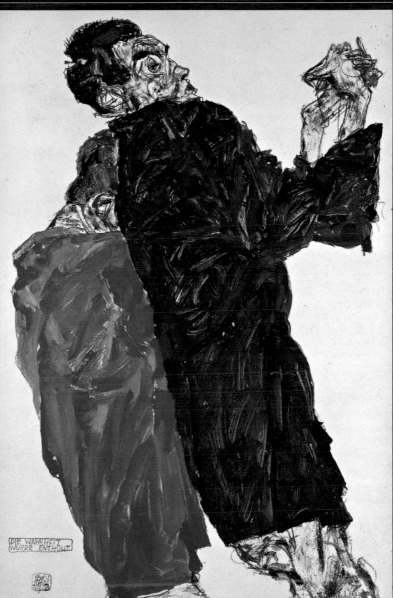

on itself, and in many outlines of mountains. These restrained, compressed upward surges emerge as lucid, stoical leitmotivs that reflected the artist-poet's own life: "I did not paint this canvas [*Hermits*] overnight; it came from experiences I have had over several years, since the death of my father; what I painted here was more a vision than images based on drawings." At no time did Schiele talk about himself or Klimt, which suggests that for him a specific explanation would have reduced the image to an allegory. The fragile couple's force of resistance gives these hermits the status of witnesses. If *Cardinal and Nun* mocks an institution, these two brothers in painting offer themselves to the world as victims crowned with roses.

This rarely published male couple from 1913 was also intended for inclusion among the great monumental works. With its unique character and suggestion of affection mingled with reticence, the enigmatic couple could perhaps be a reference to the biographical episode with Willy Lidl.

Inventory of Characters

In 1913 Schiele produced numerous self-portraits and studies of men, either nude or half-dressed in tunics or shirts, as in *Hermits*. The breathtakingly smooth lines of the early nudes now grew more lingering, and left a bumpier impression on the paper. Sometimes, for instance in his drypoints, the contours were doubled or coiled round with a soft pencil that shaded them, while the surfaces were attacked with colored pencil and gouache to make them appear thick and swollen. Finally, the work was completed with a few stitches. If the bodies appeared to have weight, their meaning was lost. Viewed mainly from the back or the side, and often foreshortened or partial, these enigmatic postures and hidden

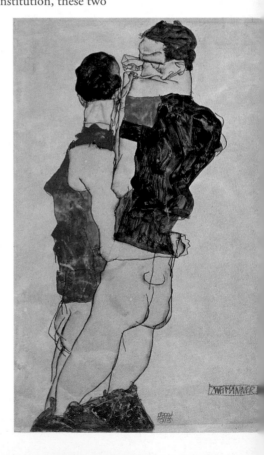

faces needed carefully handwritten titles enclosed in boxes as an aid to interpretation: *Two Men, Dancer, Fighter, The One Who Calls, Devotion, Redemption, The Melancholic, The Truth Was Revealed.*

This inventory of characters was intended to be used for a vast allegorical composition in which the forms, simply by their eurythmy, would embody a mystery even more complex than that suggested by *Hermits.* Carl Reininghausen, who owned a rare collection of works by Ferdinand Hodler, contributed to

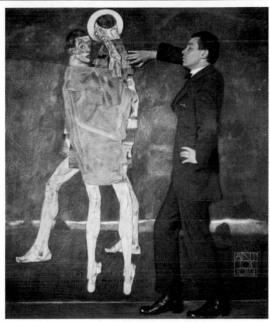

the project with ideas, interpretations, and even pictorial collaboration, and was informed by Schiele of any changes or alterations. Otto Benesch had the following recollection of *Conversion,* a painting also known as *The Blind*: "A group of about a dozen almost life-size figures, standing or moving, invented freely but inspired by friends and family. Among them one could recognize Klimt and my father, and in the features of a young man, I recognized myself."

The project was over-ambitious, however, and the painting was cut up while still unfinished. Only *Encounter,* from 1914, showing Egon and a saint with a halo, gives us an idea of what the work would have been like. Also incomplete, it was entered for a competition organized by Reininghausen at the Miethke Gallery in Vienna. Schiele was expected to win, but failed to do so. Given that he was in the middle of a huge photographic campaign that he had organized with the photographer and painter Anton Josef Trčka, he marked the occasion

Schiele photographed by Anton Josef Trčka in 1913 in front of the painting *Encounter (Self-portrait with a Saint).* This was a cut-off sample of the large compositions envisaged by Schiele, which was exhibited in 1914 at the Miethke Gallery by the collector Reininghausen. Apart from the young Austrians of his generation, such as Anton Faistauer and Paris von Gütersloh, some French artists were present, including Marie Laurencin and Raoul Dufy, since Reininghausen was a lover of French painting and regularly spent time in Paris.

by having his photograph taken in front of the work, an admission of failure that this doubly narcissistic gesture which was an attempt to hide.

Egon the Sacrificial Victim, the Man Flayed Alive

For the poster for his solo exhibition at the Arnot Gallery in 1915, he drew himself as Saint Sebastian, an image in which his conception of self-sacrifice reached its peak. The simple reading of this was that he was offering himself to the arrows of criticism and incomprehension, but as well as that, Saint Sebastian embodied his vulnerability to impressions of the outside world. Flayed alive, he transmitted the dramas of the world like a tape recorder, but here, as a sign of the times, this "man tired of life" had given up nudity and retained the monk's frock.

Schiele had difficulty finding buyers for his allegorical compositions, and never, in fact, managed to sell *Hermits*. The Munich dealer Goltz, although an avant-garde specialist, wrote in despair: "The 'isms' that were so extraordinarily necessary as a way forward and a means of destruction must now be transformed into a calmer, stronger art. Otherwise the dealer, despite his personal understanding, will be unable to carry on, and will have to turn with a heavy heart to lesser talents that are at least more accessible. . . . Even the most benevolent and well-disposed art lovers are beginning to grow impatient and are hungry for repose and clarity." For that type of collector, Schiele returned to themes that had already proved lucrative for him: puny, ailing trees and well-tried floral themes, such as sunflowers with heads too heavy to follow the sun, bending over, black, and surrounded by sharp, dried-out leaves, or charming Chinese-lantern bellflowers. In *Setting Sun* (1913), the dark autumn earth is punctuated with the yellow spots of sunflowers.

The Dead Town of Krumau Takes on Color

After a long period of restraint, color now gradually invaded Schiele's landscapes. His new versions of *Dead Town,* painted in Vienna to satisfy demand, turned into multicolored toys. Much reduced in scale (a reminder of Schiele's love of miniature railways), they showed reds

The most popular of Schiele's works were his views of towns, whose growing success and influence can still be seen in today's nostalgic Austrian kitsch (below, *Windows [Façade of a House],* 1914). Collectors were put off by his gloomy landscapes, and encouraged him to produce new variations on well-tried themes.

and yellows mingling with the whole range of grays. The houses, which had previously been treated as a compact mass, now began to breathe; little streets as narrow as cracks slipped across from one side of the Moldau to the other, and the mass of roofs was brightened up by the strident red of chimneys, drainpipes, and doorframes. Multi-colored lines of washing were restricted at first to balconies, then hung out between red poles, like rows of Chinese lanterns. Even green was allowed to intrude.

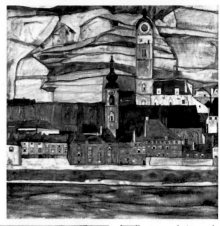

The terraced vineyards of Stein become flat patches of color, echoing the water patterns on the Danube (above: *Stein on the Danube*, 1913). This meticulous accumulation can also be seen in the houses and on the roof tiles.

"Dear Mr Hauer, Since yesterday I have been here in Vienna, and I am painting your picture of Stein, you can come and pick it up right away. The tower is no longer falling down and the bank on the other side of the Danube has been softened. As regards the large painting [*Resurrection*], I still have a great deal of work to do on it, so I must ask you to wait until September. At that point you will also see several views of Krumau on which I am currently working."
Egon Schiele

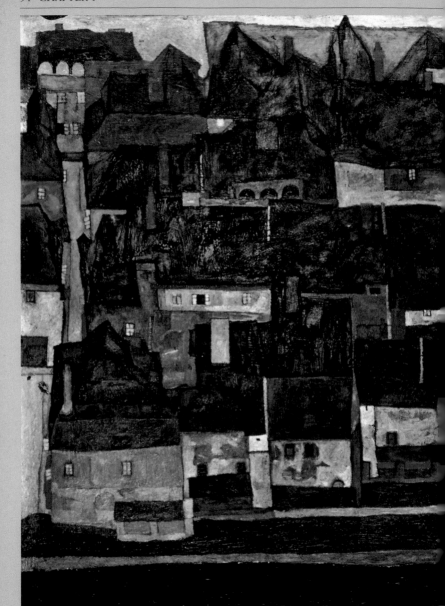

Once ill-fated, noxious, and tragic, the dead city of Krumau woke up over the years, and cast out its old curse. Although retaining the "high-angle" viewpoint that enabled him to show the town in detail, Schiele modified the centering of his images. Confined, truncated views of isolated areas gave way to much wider, more loosely constructed scenes. While previously the houses had huddled together and recoiled in fear and hatred, they now relaxed their hold and gave each other room to breathe (left, *Small Town IV. Krumau on the Moldau,* 1914). The oblique walls stood upright again, and the color white entered the town, spreading out in squares and on embankments. Streets appeared, running across the canvas like cracks, and giving light and air. The façades became colorful, with regular notes of red bringing life to the mauves and blues, and even to the yellows, which until then had been subsumed in the grim darkness of the houses. Almost eighty years before the end of a Communist regime that preserved Krumau (now Ceský Krumlov) in a brownish formalin with shades of peat, Schiele invented the lively, cheerful, well-kept international city that it is today.

The old landscapes were now dressed up in the colors of summer.

There was a danger of becoming formulaic, however, which Schiele was anxious to avoid. In 1914, the exquisite interplay of mauves and blues in *Windows* might have been insipid had it not been for its unstable, truncated composition. Stein, a small town on the Danube backed by terraced vineyards, was the subject of a short series of views, painted partly in the studio and partly from sketches. Schiele rarely painted in the open air. When he was surrounded by nature, he liked to immerse himself in impressions, which would later provide material for his work in the studio: "I also make studies, but I find and I know that drawing from nature means nothing to me, because I paint better from memory. At the moment I am mainly observing the body movement of mountains, water, trees, and flowers. Everywhere there are reminders of movements in the human body, which are similar to the rushes of joy and pain in plants."

Clients for Portraits

Another less contentious field of work was portrait painting. Klimt was concerned about Schiele after the Neulengbach affair, and introduced him to the Beer and Lederer families, who were clients of his. Serena Lederer had been painted by Klimt, and had a fifteen-year-old son, Erich, who aspired to be an artist (modeling

When Schiele came out of prison he was introduced by Gustav Klimt to the Lederers, a wealthy family of industrialists who were major clients of the Wiener Werkstätte. Klimt painted Frau Lederer and gave her painting lessons, but her 15-year-old son Erich (above, c. 1915) preferred to pay out of his own pocket for a portrait by Schiele (left: *Study for a Portrait of Erich Lederer,* and opposite page: *Portrait of Erich Lederer,* 1912). Schiele was invited to the property in Györ, where the family's distillery was located, and was fascinated not just by the luxury of their upper-class lifestyle, but also by their affability and by the keen intelligence of their son, who would later become an art historian and curator of the Albertina in Vienna.

himself on Aubrey Beardsley), and was already a collector. It was he who decided to have himself painted by Schiele. The two young men immediately struck up a friendship that proved to be lasting. The preparatory work for the portrait was done at the family's home at Györ in Hungary, and it was completed in Vienna. It showed Erich Lederer as a future aesthete, with a winning look and a dandy's pose. The model's anatomical defects — the very long face, protruding ears, fragile torso and wide pelvis—were emphasized by a low-angle perspective that turned the figure into an icon of self-will, on whose nascent energy Schiele left his own mark by showing a tense, gnarled hand clasped on his hip.

In this commissioned portrait, Schiele showed no less perceptiveness than he had done in *Hermits*. Another example of this was his double portrait of Heinrich Benesch and his son Otto. Benesch was the least wealthy but most understanding of his patrons, and Schiele viewed him as something of a good samaritan. He had to make do literally with the artist's scraps— drawings that were destined for the wastebasket—and the few small purchases that he could afford. Schiele treated his loyal supporter rather harshly, and sometimes Benesch rebelled:

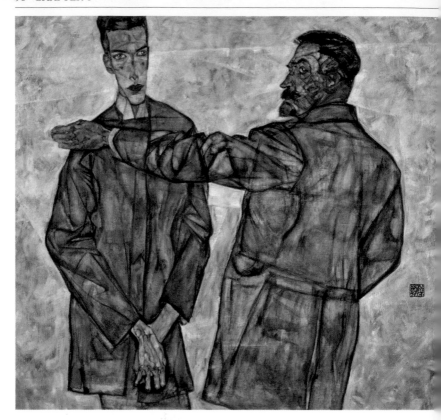

"You have already promised twice to draw me, but to this day you have never kept your promise. You have done this affectionate favor for all your art lovers, so why not for me too? Am I not worthy of this attention? It's for myself that I want it, to have some proof of your friendship and not at all so that I can own a portrait."

His son Otto recalled their sittings: "There were any number of preparatory drawings for a portrait. . . . Schiele drew quickly, the pencil slid over the white surface of the paper as if guided by a spirit hand, as if it was effortless. He held it as a Far Eastern painter holds his brush. He never rubbed anything out, and if the model moved, the new lines were added to the old ones with

More modest than the Lederers—the father was only a railway engineer—the Benesches treated the artist with steadfast and admirable kindness (above: *Heinrich and Otto Benesch, Double Portrait,* 1913). In each of his letters, Herr Benesch sent an affectionate word to Wally, whom most of Schiele's clients ignored.

the same infallible assurance. . . . He never added color to his drawings in front of the model, but always afterward, from memory."

Like the models in *Hermits,* the two men stand out against a gray background streaked with lines and brightened by rings of light. The father is turning his back but showing his profile, while the son stares into the distance. The contrast between Benesch's stocky figure and Otto's rangy one is accentuated by the father's outstretched arm, which crosses the axis of his son's body. Otto's elongated face breaks through the upper border of the painting, and his eyes give off a magnetic ray that ignores the father and is lost in the distance. Benesch did not have enough money to buy the work, but his whole family was kept in suspense while it was being painted: "It was only later that we realized its true meaning. Had Schiele consciously or unconsciously understood the psychological background to the situation? Heinrich Benesch loved to dominate. His son's flow of thought was beginning to irritate him. In this boy, who was seventeen at the time, Schiele recognized the gaze into the world of the mind, beyond all limits, and expressed it in this painting: a world of the mind where Otto dominated quite naturally."

From Idyll to Marriage

In January 1914, an idyll began between Schiele and two pretty neighbors who lived

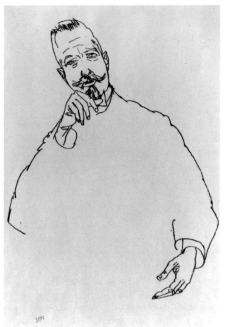

During the many sittings that preceded the painting of the portrait, the artist produced one drawing after another at breathtaking speed, as his eyes flitted rapidly between the paper and the model (above, *Sketch of Heinrich Benesch,* 1913). Clearly visible in the drawings, the paternal authoritarianism of Benesch, often masked by affability, is rendered vividly in the painting, where the formal opposition of the figures conveys the antagonism between father and son (left: *Self-portrait,* 1913).

on the other side of Hietzingerhauptstrasse, where his studio was. The artist would stand at his window and wave somewhat improper self-portraits at the young Harms ladies, who laughed but continued to spurn his invitations. One day when he bumped into them unexpectedly in the street, his pleasure at seeing them drove him to indulge in eccentric "artistic" behavior. After that he tried to cajole them: "Dearest young lady! I do not know which of you, the blonde or the brunette, is called Ada. You are both as terrible as I am. We may not always be neighbors, because I am thinking of moving to Paris, where I have had some offers. Why don't you come and visit me? I know that people might think it was unsuitable, but I will do you no more harm than your favorite greyhound. Do answer me. With warmest greetings to you *and to your sister.*"

A year later Schiele, who had just been exempted from enlistment in the army, ended a letter to Roessler with: "Am thinking of marrying—advantageously— probably not Wally." Meanwhile the missives had multiplied, inviting the Misses Harms for walks and trips to the cinema, in a threesome or a foursome with Wally, who no doubt served as a go-between. Egon, with all the aura that being an artist conferred on him, amused the girls but made their family anxious. Their father was a former railway engineer. Egon became civilized and gave up being a "ruffian." His favorite was Edith, the blonde, who was three years younger than he was, but at the same time he did not want to give up Wally. It was as if marrying meant falling once and for all into the ranks, and even the ranks of the railway. In an emotional letter—many letters passed from one side of the street

"Dear Fraülein Ed. and Ad. or Ad. and Ed., I believe that your gracious Mama will give you permission to come to the cinema or the Apollo, or where you like with me and Wally. Rest assured that I am in fact a very different person— the "Ruffian" was just an act because I was so excited—so if you feel like putting your trust in us, I would be very happy, my day will be yours. With my warmest greetings."

Letter to Adele and Edith Harms, December 10, 1914 (below)

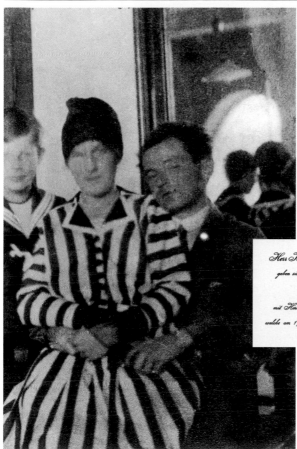

Of the two Harms sisters, Schiele finally chose the younger one, Edith (left, Edith and Egon with their nephew, in 1915). It was a suitable, sensible marriage, but it took place in a hurry, on the eve of departure for the army barracks in Prague, during the second year of the war (below, wedding invitation for June 17 at the Protestant church). As in *Gone with the Wind*, the wedding dress was made out of old curtains. Having acted

Herr Johann und Frau Josefine Harms geben sich die Ehre, die Vermählung ihrer Tochter

Edith

mit Herrn *Egon Schiele*, akad. Maler welche am 17. Juni 1915 in der ev. Kirche stattgefunden hat, anzuzeigen.

as Egon's chaperone, Wally was forced to give way to the young bride.

"I love you, but do not think that my love is blind and that my jealousy can tolerate my being on an equal footing with Wally. No, as I have already said, what I want is simply that everything should be decent. What are your ideas on the subject?"

Edith Harms to Egon, April 1915

to the other—Edith insisted that everything be done "properly" and demanded that Wally be dismissed. In the spring of 1915 a new draft board declared Egon fit for service, and events started to move quickly. In a Protestant church (Edith was a Protestant) the marriage was celebrated on June 17, 1915, in the absence of Marie Schiele. The couple took off on an unusual honeymoon in Prague, where Egon was quartered in barracks and Edith stayed at the Paris Hotel.

With marriage and the war, adolescence was now finally in the past. Schiele's return to Vienna after his release from the army confirmed his role as an artist whose mission would be fulfilled in peacetime. The death of Klimt and Schiele's exhibition at the Secession established him as the "Prince" of Viennese artists. The prince was destined for tragedy, however; a few months later he died of Spanish influenza, as did Edith and the child they were expecting.

CHAPTER 5

A RECOGNIZED ARTIST

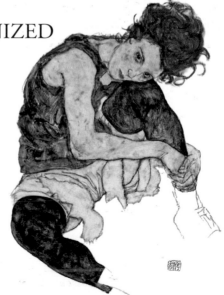

In the numerous female nudes from 1918, it is difficult to distinguish between the professional models and the two Harms sisters, who were vying for the artist's favors (left, in his studio in 1916). One can barely tell Adele's slightly square face apart from Edith's finer one, which can however sometimes be recognized by its melancholy expression (right: *Seated Woman with Bent Knee*, 1917).

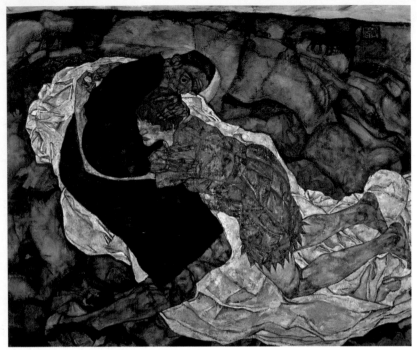

Death and the Maiden

The break with Wally took place without any high drama, in a café. Right until the last moment, Egon thought that he could arrange a compromise by offering her a contract that "would guarantee that every year they spent two weeks together in summer." Wally was dumbfounded, and refused. Both she and Edith were much more resolute in this situation than the man they were dealing with. By the double standards of the time, however, the choice of a "good" girl condemned the other one as "bad." This was the last time Egon ever saw Wally, who joined the Red Cross and died of scarlet fever on the Balkan front. The artist's guilt was plain to see in *Death and the Maiden* (1915). Since Hans Baldung Grien and Niklaus Manuel Deutsch, this had been a traditional theme in German painting, enabling the artist to show the generous curves of a naked beauty in the erotically

Death and the Maiden had been a recurrent theme in German painting since the Renaissance, and Schiele's version of it was an admission of the debt he owed to his first companion, Wally, whom he had to give up when he married Edith Harms in 1915 (above: *Death and the Maiden,* 1915). For the last time he took on the role of death, which was also the death of the self. Finally forgetting himself, he now looked outward at the world and other people.

charged presence of a skeleton. "Be well-disposed, I am no brute and you can sleep softly in my arms, give me your hand, tender beauty, I am a friend," sings Death in Schubert's lied. But the girl here, whom we recognize as Wally, does not look very well-disposed, and there is nothing friendly about Death in the form of Egon.

This was not the first time that Schiele had taken on this role; in 1911 he had been the hollow-eyed double in *Self-seers II,* and in the same year he appeared as the monk in *Death and the Mother.* In both cases he portrayed his character without pathos; in his vision of the world, life and death could conjoin without violence. In this case, however, death was not metaphysical but real. In his monk's frock and with a guilty look in his eye, Schiele is placing a vampire's kiss on Wally's neck, while she clings to him without daring to kiss him; the folds of the frock are deliberately arranged in such a way that her arms already look like those of a skeleton. Not only is *Death and the Maiden* the ultimate embodiment of a *Kiss* that is breaking up, it also announces another separation, that of Schiele from himself.

A final image of narcissism and dual personality is *Entschwebung (Disappearance, Floating Away),* which shows Schiele with his feet on the ground and his eyes boring into the spectator, this time taking his leave from the hollow-eyed ghost. In breaking so brutally with the past there was clearly a risk that the artist himself would be reduced to a mere shadowy outline. Was Schiele, so proud of his status as creator, really destined to play the role of the good husband, and perhaps the good father as well? He showed his own doubts about this in *Seated Couple,* where Edith holds on

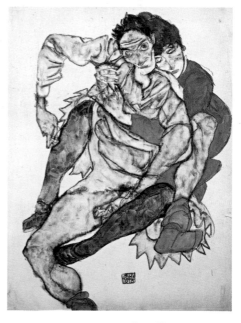

Having been subjected to obsessional analyses, the body had now been put back together and made whole again, and yet reality was still elusive (below: *Seated Couple, Egon and Edith Schiele*). Form had been rediscovered, but it tried to make one final breakaway. The model's ghost takes the place of the real body, and its face has the vacant expression of a doll. Taking the role of the reality principle, Edith Schiele tries to hang on to an inert Egon.

desperately to an Egon who is collapsing like a rag doll.

After Neulengbach—as we can see from the drawings—the body was no longer a matter for experimentation, but for doubt. Faces became schematic, gestures were stiff and puppetlike, and garments were ample. It seemed that the time had come for concealment; one member of the couple was always escaping from the other. In 1914, *Man and Woman (Lovers I)* showed the two bodies with strongly contrasting flesh tints and also in very different positions; the woman was on her knees and turned in on herself, while the man was stretched out with his head raised, and looking directly at the spectator.

The Difficulties of Garrison Life

The stay in Prague was a testing time. Egon was shut away with 10,000 Czech conscripts in a vast hall where they slept on straw, like cattle. The Czechs were Russophiles, so they were closely supervised and those who tried to escape were cold-bloodedly shot. Edith and Egon could only speak to one another, and even then they were separated by a grill. They never knew how long it would be before their next meeting, and the waiting periods were painful. Alone in this foreign city, Edith enjoyed meeting up again with her friend Jenö Farkas, who went everywhere with her and even fell in love with her. "Even though the temptation is great, I know that I am capable of resisting all temptations of this sort. Egon can count on me," she wrote in her diary. Then at Neuhaus, where Egon was stationed next, Edith was courted by a non-commissioned officer. When Schiele became angry about it

In *Disappearance, Floating Away,* 1915 (below: detail) the last large representation of the double, also known as *Blind Man II,* celebrates the arrival—or one might be tempted to say the landing—of the artist in the real world. Above him floats his blind double, who presumably is being persuaded to disappear. The bright, cheerful flowers dotted over the canvas contribute to the sense of a joyful reunion, which the painter's expression is still struggling to convey.

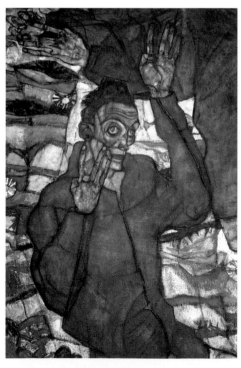

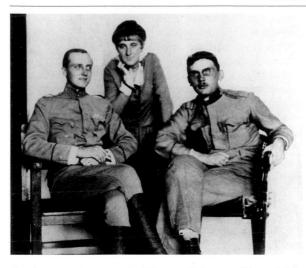

When Schiele was posted to far-off garrisons, Edith was able to join him and thus stay close to her husband (left, with some of Egon's regimental comrades, c. 1916). This led to happy reunions, but also to the first bouts of jealousy from Egon, since Edith did not remain immune to the charm of some of his friends.

On one surveillance mission Schiele did a series of drawings of Russian prisoners, whose pacifism reinforced his own (*Russian Prisoner of War, Grigori Kladjishuili,* 1916).

she threatened to return to Vienna. "He wept like a child. He said, among other things, that if I was in Vienna while he was here, he would go mad. . . . He would throw himself in the lake. . . . He fell to pieces when I threatened to leave," she wrote. Schiele had no enthusiasm for life in the barracks, not least because it was difficult to feel patriotic in this "nowhere land" of the double monarchy. "In the evenings we have talked about the war, and it is astonishing just how unhappy all the soldiers I have met so far can become. Everyone wants the war to end, whatever the outcome. For my part, it means nothing at all to me where I live, in other words which nation I belong to. In any case, I am more tempted by those on the other side, our enemies; their countries are much more interesting than ours; it is over there that there is real freedom, and people who think, much more than in our country. What can one say about the war at this time? That every extra hour is a waste."

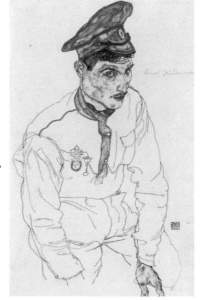

The couple's relationship improved somewhat when Schiele was stationed closer to Vienna. "She may have had fun when I could not come out, but we were not as united as we are now," wrote Egon, who was painting his first large portrait of Edith, like another big doll, in her multicolored striped dress, gauche stance, and absent gaze. The artist apparently found it hard to give flesh to his wife. In the few erotic drawings of the time where she may be recognizable, he hid her face.

Clearly the ups and downs of army life were not good for their life together. During a posting to Mühling, in beautiful countryside where they rented a little house near

Although Schiele had given up erotic representations of children and adolescents since Neulengbach, he continued to be fascinated by lesbian love, whether staged by him or practiced by some of his models (below: *Two Reclining Girls Embracing,* 1915). As in the drawing of Egon and Edith (page 105), one of the partners is holding on with

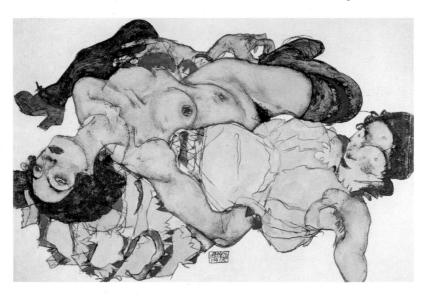

the camp, the rare occasions when the couple could steal some time together away from military life did not appease Edith, who found it hard to be independent: "I could be happy here, if solitude did not weigh on me so heavily. The few moments that Egon spends with me go by too quickly, and the rest of the time drags on forever." Egon then gave her a notebook and suggested that she should try her hand at drawing and writing down what she saw.

difficulty to the other, who has turned into a rag doll with inexpressive features. This was a way in which the artist could still show the buxom flesh of the "living" woman.

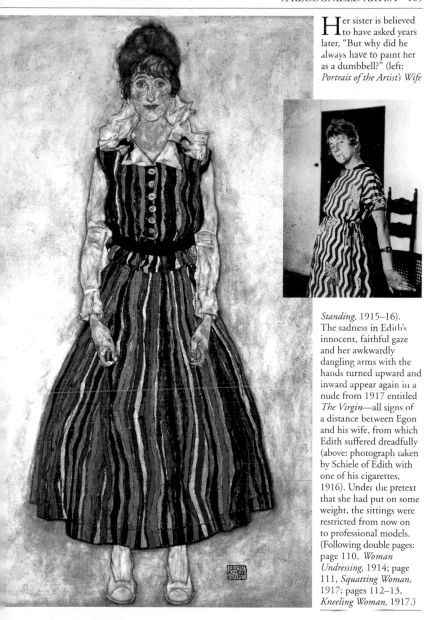

Her sister is believed to have asked years later, "But why did he always have to paint her as a dumbbell?" (left: *Portrait of the Artist's Wife Standing,* 1915–16). The sadness in Edith's innocent, faithful gaze and her awkwardly dangling arms with the hands turned upward and inward appear again in a nude from 1917 entitled *The Virgin*—all signs of a distance between Egon and his wife, from which Edith suffered dreadfully (above: photograph taken by Schiele of Edith with one of his cigarettes, 1916). Under the pretext that she had put on some weight, the sittings were restricted from now on to professional models. (Following double pages: page 110, *Woman Undressing,* 1914; page 111, *Squatting Woman,* 1917; pages 112–13, *Kneeling Woman,* 1917.)

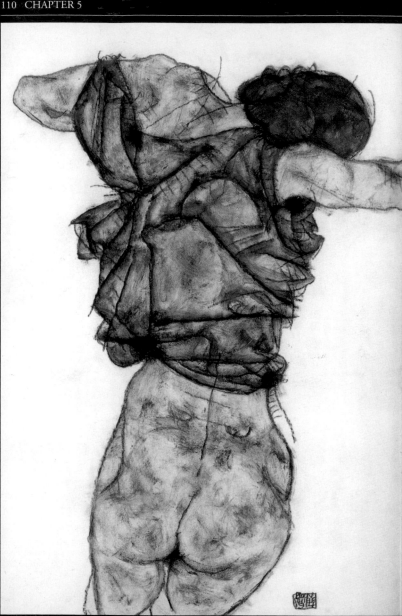

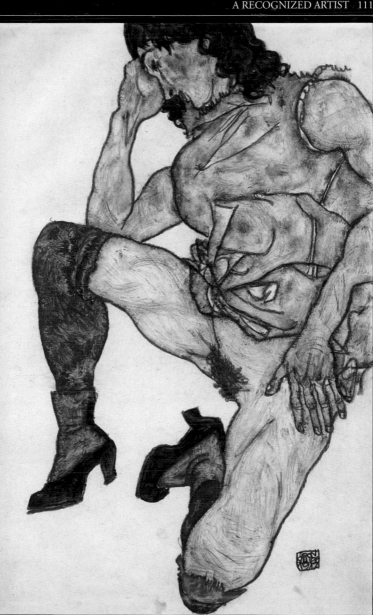

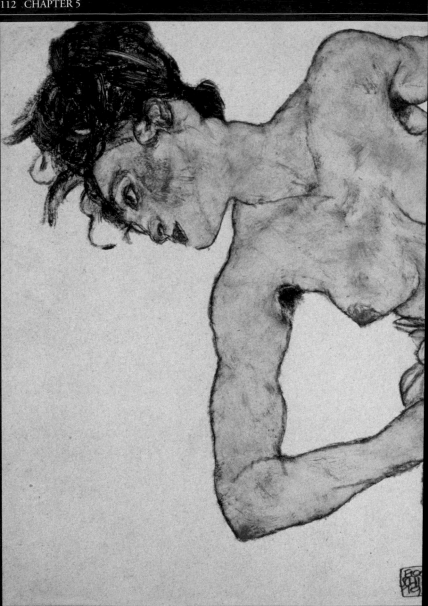

That Is Where I Want to Start All over Again

This difficult apprenticeship to life as a couple came to an end when Schiele was posted to the supply corps in Vienna, which enabled him to move back into his studio in Hietzing and re-establish contact with the artistic life. Being back in the capital galvanized him into action. His favorite confidant was still Anton Peschka, who meanwhile had married Schiele's sister Gerti. Never reluctant to spend money, the artist dreamed of moving to a new studio surrounded by a garden, "with a game of skittles." "We are going to move very soon; that is where I want to start all over again; I have a feeling that until now I have just been sharpening my sword. Let's hope that the war ends this year so that we can be together more often," he wrote to Peschka in January.

Some piles of books, a candlestick, the flapping curtain—this was *The Artist's Study* (1914). By taking a low-angle view on a slanting plane, as in the theater, the artist emphasized the appearance of accumulated layers, as in his landscapes.

He explained his plans to an ex-officer: "It is a question of art and the future. Men of culture can rebuild nations; all it takes is for a few men to decide to do it." Twenty years after the creation of the Secession, he was encouraged by Josef Hoffmann and Gustav Klimt: "Dear Professor Hoffmann, I learned with great joy of your interest in our idea . . . I believe in great, free art—in men who will come in search of knowledge. When we are trying

to decide on a concept for our exhibitions, we will let you know so that you can discuss it with us."

The Project for a Meeting-Place with the Public

Schiele's plan had nothing to do with organizing a new association of artists. The horrors of war, the destruction of an industrial society that believed in progress, the solitude of creative artists reduced to inactivity, and fear of the complete collapse of civilization all made him dream of a *Kunsthalle*, a hall for art, a place for coming together and meeting where creators and the public could strive for the very uncertain future of Austria. Artists and creators would take over from the politicians who had failed. "With this in mind, some independent young people have come together with the aim of creating a spiritual meeting place, and have rented a space that can also serve as a conference hall so painters, sculptors, architects, musicians, and poets may have the possibility of coming in contact with the public, in order to fight against the cultural disintegration that is imminent." The project's emphasis on an Austrian slant was unexpected. Utopian visions in Germany at this time were influenced by internationalism and Marxist socialism, and would result, for example, in the founding in 1919 of the Bauhaus in Weimar.

Schiele's altruism quickly found expression when in May he organized a "War Exhibition" in which he brought together the works of his artist friends.

Schiele in his studio in 1915. The black Wiener Werkstätte display cabinet contains a collection of children's toys and folk objects, including a Javanese puppet. The aesthetic here is in tune with the Blaue Reiter (blue rider) movement, and the first issue of its review, with a Kandinsky engraving on the cover, is displayed on the left. Schiele had seen their work in Hans Goltz's Munich gallery, where his own work had been shown.

He renamed his *Resurrection,* which he showed as *Heroes' Graves, Resurrection, Fragment for a Mausoleum.* His idea now was to build a piece of sacred architecture that would contain his large allegorical paintings and be a temple for them, a mausoleum symbolizing the awaited resurrection of contemporary society.

Invitation to the Secession

It was at this time that Schiele achieved recognition. Franz Martin Haberditzel, the director of the state-run Moderne Galerie, bought a group of his drawings, which would later form the nucleus of the Schiele collection at the Albertina. The bookseller Richard Lanyi published a portfolio of lithographs of his work, and produced postcard reproductions which made Schiele known to a wider public. His paintings were exhibited in neutral countries, where Austria was trying to dissociate itself from Germany and harken back to its existence as a civilized nation. Even Hans Goltz in Munich began to believe in Schiele. The decisive event for the artist, however, came when the Secession invited him to rejoin them and organize the spring exhibition of 1918. He showed nineteen paintings and a dozen drawings. They were all sold, and for the first time achieved substantial prices.

The only shadow cast over his success was the death of Klimt in February. In an uncompleted painting from 1918, entitled *Friends* or *Round Table,* Schiele had tried to celebrate the artistic brotherhood that he wanted to create with the *Kunsthalle.* Central to the table and the project were

As the war was coming to an end amid a general feeling of helplessness, artists and thinkers seemed to want to take up the challenge and start afresh on what would soon be the ruins of the Austro-Hungarian Empire, otherwise known as "Kakania." Less radical than their German contemporaries who would unite their hopes under the red and black flags of the left, the Austrian intelligentsia sought to come together under the banner of talent. Schiele dreamed of a "great monumental art" worthy of enlightening humanity as to its destiny, and planned to create a special place where painters, sculptors, musicians, and dancers could meet and bring together their audiences (left: *Plan for a Mausoleum,* c. 1918). Ten years after the elitist Kunstschau, this would be a place that was more open and forward looking.

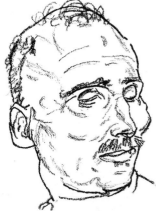

Klimt and Schiele, with six other artists sitting around them. The simplicity of the meal and the unadorned furniture, tonsures and monks' robes all alluded not just to the monastic brotherhood of artists, but also to a *Last Supper* that Schiele was planning for at this time. Here, Schiele was no longer Klimt's John the Baptist. Together they formed the vertical axis of the table, which continued in an L shape, suggesting that the seating arrangement was provisional and open to change. For the Secession poster, Schiele used the same composition but replaced the plates of food by books.

This was no longer a time for feasting but for reflection, and Klimt's chair was now empty.

A New Style for New Portraits

With his return to creative activity, the successes and honors he had achieved, and Klimt's death, Schiele was now the leader among Austrian painters. As a sign of this achievement, he received more and more commissions for portraits. These still came from men in artistic circles, but also from women in Viennese high society. It is difficult to imagine Schiele as a society portraitist, and impossible to define a clear profile for him in that role. We can see, however, how his work in the genre evolved.

The first portraits in 1910 had been notable for their lack of color and background, and their figures with no volume and stiff, bent limbs, like those of the Javanese

Elected by the Secession, which in 1918 was celebrating its 20th anniversary, Schiele arranged the 49th exhibition around a central hall in which his work took pride of place. It was a critical as well as a commercial success, but his joy at being fêted as the leading painter in Austria was clouded by the death of Klimt (opposite page, bottom, drawn by Schiele on his deathbed).

puppets of which Schiele was so fond. *Hermits* and the double Benesch portrait, both featuring more than one person shown against a cottony background, showed the last of a series of postures where the metaphysical message was emphasized by codified body movements.

The first and last portrait of a woman other than Edith was that of Friederike Maria Beer, the daughter of a client and friend of Klimt's. It shows the difficulty that the artist encountered; in order to place the young woman within an abstract setting, he pinned her to the ground like an exotic insect, and added a note of confusion by scattering Indian dolls over her over-opulent Wiener Werkstätte dress. This gave the figure a vaguely Egyptian, disembodied quality, but even so it was lacking in expressive force.

In the portrait of his father-in-law Johann Harms, Schiele—for the first time—showed his model sitting in a chair, which was one of those that he had designed in a minimal style for his own studio. This basic monastic chair produced an interplay of simple right angles between square-section lengths of wood, and was enough on its own to introduce volume, depth, and perspective against a background that was still indistinct. In its turn this "base throne" implied a body with volume, even if the old man's form seemed to be sliding drowsily along a diagonal. The melancholy note here was accentuated by the direction of the right hand, while Harms' weariness is shown by the enormous right hand, fashioned by labor but ready for the ultimate release.

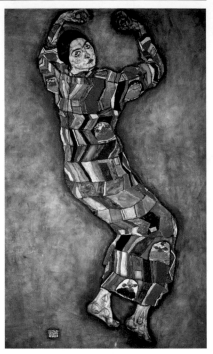

The Conquest of Space

In the portrait of Franz Martin Haberditzl, the director of the modern Austrian collections, three additional right

"My family had brought back some little dolls from La Paz. One day I brought some of them in because I knew that Schiele might like them. He was delighted, and asked me to lie down on a mattress and put my arms around a cushion, then scattered the little dolls over my dress like confetti, one on my arm, one on my back, another on my shoulders, two on my legs, and like that he incorporated them into the portrait."
Friederike Maria Beer
(above: *Portrait*, 1914)

angles complemented the perspectivist cube suggested by the chair; the background was taking shape. With Victor Ritter von Bauer, the colored stripes on the seat cushion and the emphasis on the base gave the chair all its symbolic force, while the wooden slats on the studio walls put the finishing touches to the perspective. The figure's outline stood out clearly and was enhanced by a few notes of color.

In the last two portraits, of Schiele's gallery owner Guido Arnot and Hugo Koller, this conquest of space was confirmed. Arnot was still surrounded by talismanic objects and Schiele's studio furniture, but the figure sitting with his hands crossed was amply framed by the table in the foreground, the row of books, and the corner iron. There was an equal sense of enclosure around the form of Hugo Kollner, who this time was shown in his own armchair, surrounded by his collection of books. The layered accumulation of objects, with which the artist was familiar from his numerous sketches of war supply depots, had now become an obsession; sitting very firmly in his armchair, Kollner was overrun and hemmed in by books that threatened to engulf him. Rediscovered and personalized, space now surrounded bodies that had acquired weight, and a personality independent of the artist's own.

This did not prevent Schiele from painting models who were closer to him and more "likeable," in portraits such as the uncompleted one of Paris von Gütersloh, an artist friend from the early days. Here the throne became more abstract, while the

While he never made a name for himself with portraits of women, he had more success with those of men, whether family members such as his father-in-law Harms (below, 1916), gallery owners and collectors, or fellow artists such as Arnold Schoenberg. Following double page: left, *Portrait of Dr. Hugo Koller,* 1918; right, *Portrait of Victor Ritter von Bauer,* 1918; in these portraits he reappropriated the space in which the model posed.

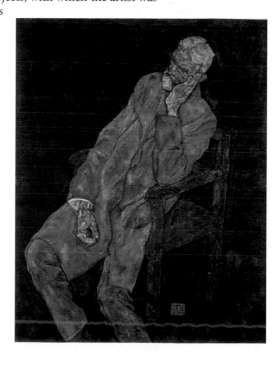

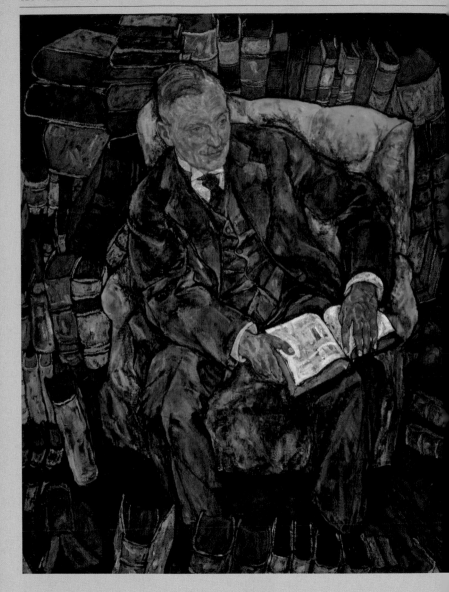

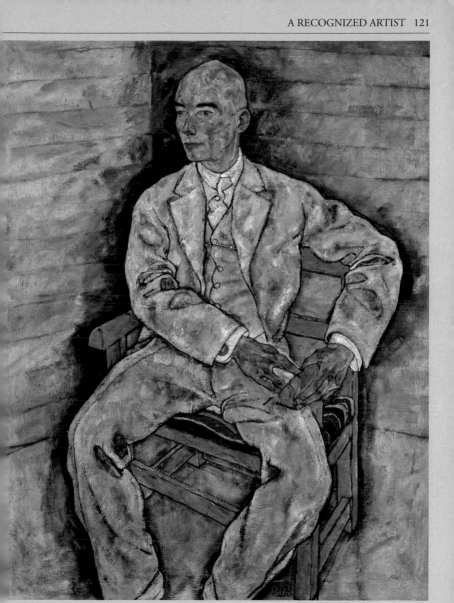

hieratic frontal view and the language of the hands—
one palm seemed to respond to the other—restored a
sense of collusion with the model. The model's easily
recognizable broken nose led to a graphic treatment of the
face, which vibrated with all the hypnotic energy of this
other brother in art.

Sittings at the Studio

Artistic life had resumed, and with it, sittings with
models. Schiele's notebooks were full of appointments
with girls called K or S. One of them had a preference
for women, and came to pose with her girlfriend.
The nudes of the time show that the feeling of
helplessness that followed
Neulengbach had now
been overcome. The
bodies had form again,
but this became too
allusive—at twenty-eight
years of age, Schiele was
no Matisse. The simple
contours were not enough
to give life to these bodies
with no relief or color.
Sometimes the double
gaze of the eye and the
vagina appeared like a
memory, suddenly taking
the spectator back to the
temptations of the past.
Edith Schiele, having
complained of her
loneliness in distant
garrison towns, now felt
neglected by her artist
husband, who found her
too "podgy." Her slimmer,
saucier brunette sister
Adele proved to be
a highly satisfactory
replacement. Not only
was she quite happy to

In this photograph by
Egon, Edith Schiele is
posing in her husband's
studio, standing with her
dog, Lord, in front of *The
Virgin*, a monumental
painting in which Edith's
posture is the same as in
her portrait in the striped
dress (page 109). There
is pathos in this image
of the "visiting spouse,"
whose bearing is very
different from the poses
that Schiele normally
demanded of his models.

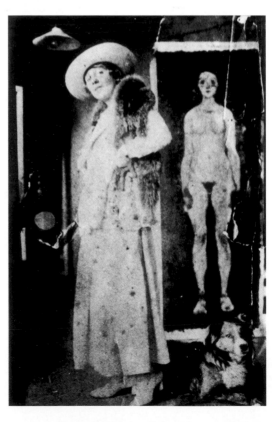

wear ankle boots, tights and frills, she is also thought on several occasions to have departed from the rules of her "nun's life" for his sake. Edith put up with this, but was less able to bear being left on the sidelines: "Egon certainly loves me in his own way, but he will not tell me the slightest thing about what he is thinking. He leaves me out of everything, and will not let me take part in developing a single idea. Would things be better if I had a child? That way I would have a part of him, which I would be entitled to take care of," she wrote in her diary on April 16, 1918.

Adele Harms had a physique very similar to that of some of the artist's models (below: *Reclining Woman with Green Stockings,* 1917), and liked to dress like a "loose woman" when posing for her brother-in-law, who continued to have a fondness for "suggestive" poses (left: Adele photographed by Schiele in the studio, c. 1917). "That's all he ever thought about," admitted his models. Edith encouraged the huge output of nudes with linear features, many of which were painted in 1918.

Ambiguous allegories

Despite the portrait commissions, the return to landscape painting, and the lengthy sittings, Schiele was able to continue with his monumental painting project.

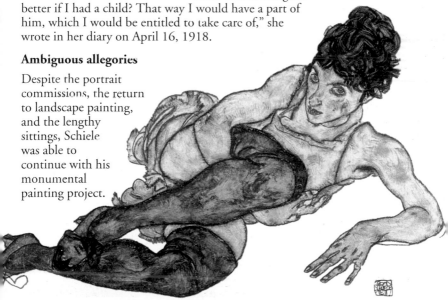

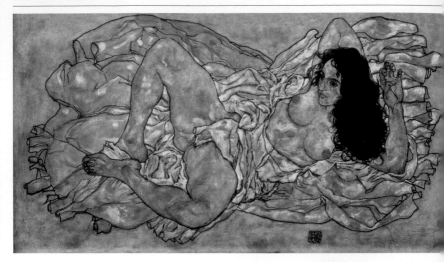

This could have incorporated most of his later compositions, such as *The Virgin, Lovers II,* and *Three Standing Women,* which were intended to make up cycles. The rediscovery of bodies and space, volume and relief, helped to increase the accessibility of works which were now intended for everyone. The anecdote had now been turned into an exemplary image that conveyed a message. And yet nothing could be more enigmatic than Schiele's late compositions, forever cut off from their destination. As separate elements of a hypothetical collection, they sometimes appear to be trivial, as in *Reclining Nude,* where solitary pleasure is displayed with no sense of anxiety. Others, such as *Lovers II,* take up a theme that the artist has dealt with before. Here the incomprehension and solitude of the lovers seem to give way to a greater closeness which as yet is timid. Seen out of their context and unfinished, however, the couples of men and squatting women will never be fully understood.

When the Child Appears

It is in this context that we must see *The Family,* which is regarded as the artist's will and testament. The painting was presented to the Secession in April and shown at the exhibition, with the simple title *Squatting*

Couple. Man and Woman, while the two other "squatting couples" painted at the time but never completed were of the same sex. For Schiele, the presence of the child was not enough to create "a family." From the numerous preparatory sketches of the baby, it is clear that he saw it as "posing a problem." Lying down or standing, it would have altered the geometrical overlap of the couple. Each member of this family exists separately, in isolation, and none of them is looking at or touching the others; the woman lowers her head in resignation toward the ground, the man's questioning, indecisive, gaze is directed at the spectator, and the child, hanging on to a miserable scrap of cloth, stares anxiously outward.

As a latter-day Holy Family fashioned by centuries of Christianity, an elemental unit seen by the positivists as the "bedrock of society," this "family" is hardly

According to Dr. Leopold, the owner of *Reclining Nude* (opposite page, 1917), the model was originally showing her genitals. Was a subject acceptable in a small work scandalous in a larger format? This had been debated in Western painting ever since Titian's *Venus of Urbino,* with her equivocally placed left hand. Since his trial, Schiele had given up nude self-portraits, but in 1917 he reappeared naked in *Lovers II* (1917), a distant variation on Klimt's *Kiss.*

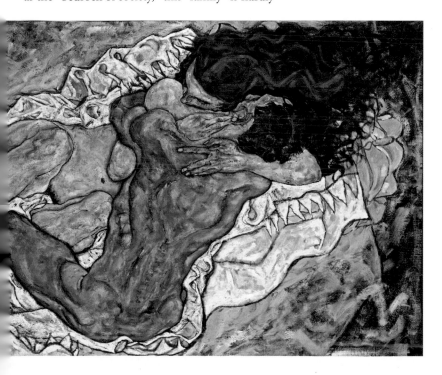

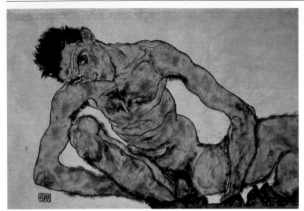

Much ink has flowed on the subject of *The Family* (opposite page and below, preparatory sketches). Is this a model of the ideal couple, or a portrait of the Schiele family? Made up of upward and downward parabolas, the composition resolves itself into an upturned pyramid, which in reverse would represent the classic formation of the Holy Family. The brown, pink, and white flesh tints of the figures contribute further to their paradoxical isolation. Although Egon is in one of his favorite poses (above, *Nude Self-portrait, Squatting,* 1916), the female figure bears little resemblance to Edith.

convincing. It is not hard to see why the artist entitled it *Squatting Couple*. But why did it become *The Family*?

A Painting as a Will and Testament

Looked at with hindsight, the painting may seem to contain a sense of warning, suggesting that Schiele foresaw the fate that was to befall him; on October 31, 1918, Edith, who was several months pregnant, died of Spanish influenza, and Egon survived her by only three days. It was a brutal end to three lives and an artist's work that was in the midst of profound change. Did this painting represent a premonition or a rejection of paternity? Was it intended to be included with the other couples in a larger reflection on sex and death? Schiele had little time for Darwinian debates; as a spiritualist, he was more preoccupied with the continuity of the individual than the survival of the species, and more interested in the enigma of each individual life than in the value of a "family" to which he belonged only for reasons of convention. It could be that he had ceased to regard the family as an asset at all; or perhaps the presence of the other same-sex couples would eventually have added to the debate.

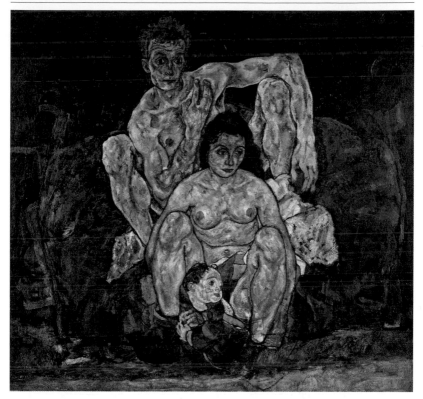

With the artist's sudden death at twenty-eight, his life and work were halted in midstream. There are many things that we will never know: what direction Schiele was pointing us in, what treasures we were deprived of by his death, whether his work was about to reach perfection or become banal. The return to clarity and order that can be seen in the portraits, nudes, and landscapes brought with it a touch of kitsch, but where would it have led? Would it have given way to a cruder, more aggressive realism, and then perhaps to Abstract Expressionism? Had these developments occurred, they might well have deprived the work of Schiele's youth of the density in it that still astonishes us today.

"Schiele was one of those who, being solidly armed, can appear before their judge at any moment. I am convinced that he gave us everything he had to give us; . . . simply because he concentrated all his vitality within a space of time that he raced through at full speed."
Hans Tietze, 1919

Page 128, *Self-portrait with Arm Twisted above Head,* 1910

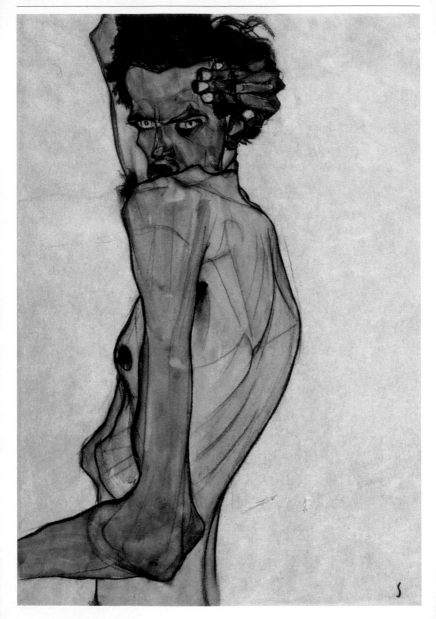

DOCUMENTS

Prose Poems and Sketches

Schiele's aesthetic statements, autobiographical fragments, and short, on-the-spot jottings have a poetic quality that places them in parallel with the musical experiments of the time. His use of rhythm and assonance gives these simple incantations a restrained lyricism that is reinforced by the use of repetition and thematic variations. Under the pantheistic gaze of the artist, people and objects enter an indefinite cycle of metamorphosis.

MANIFESTO OF THE NEUKUNSTGRUPPE (NEW ART GROUP), 1909

We are. And are we not all called (we who are exhibiting today at Pisko's Gallery) at this time? All of us are first of all men of our time, who have found the direction of our time. Many of us are artists; by artist I do not mean the man with titles and position, but the one who is called. Art always remains the same, there is no such thing as new art. There are new artists . . . but very few. The new artist is and must necessarily be himself, he must be a creator and build the foundations absolutely on his own, without relying on the past or tradition. Only then is he a "new artist." Each one of us must be himself. Only then will the name of our association be justified.

Anyone who lays claim to this title must be absolutely aware that he can exist on his own and have at least some confidence in the future.

There are certainly still many "new artists" who build on the basis of themselves and can create alone.

Formula is their antithesis.

All new artists create in complete solitude, for themselves alone, and they create what they want. They give form to everything that exists and draw a portrait of it. Today the only way their contemporaries can truly appreciate their work is through exhibitions. The exhibition is now indispensable. At every period of his life, the artist shows a piece of it, and it is always through a great experience in the individual life of the artist that a new period begins. How long this lasts depends on the quality of the impression that springs from it and gradually grows in substance. Once the artist has completely given form to his experience, an exhibition can take place.

Manifesto republished in *Die Aktion* in 1916.

PROSE POEMS OF 1910

Sketch for a Self-portrait

In my veins flows an old German blood, and I often feel the spirit of my ancestors come back to life in me. The great-grandson of Friedrich Karl Schiele, Aulic Councilor for Justice and Oberbürgermeister of Bernburg in the duchy of Anhalt, I was born on June 12, 1890, in Tulln on the Danube, of a Viennese father and a mother from Krumau. I took in the profound poetic impressions of childhood in a flat landscape with springtime avenues and raging storms. In those early days, it was as if I could already hear and breathe in the wonderful flowers, the silent gardens, and the birds, in whose shining eyes I could see my pink-tinged reflection. Often my eyes misted over with tears when it was autumn. In spring, I dreamed of the universal music of life, then delighted in the magnificence of summer, and laughed when, at the very heart of its splendor, I pictured the snowy whiteness of winter. Until that time I lived in joy, in a joyous alternation between serenity and melancholy. Then came the time of constraint and schools without life, the elementary school in Tulln, then high school in Klosterneuburg. I arrived in towns which seemed almost immense and dead, and my heart was in mourning. At that time, I saw my father die. For me my uncouth masters were always my enemies. Like others, they did not understand me. The greatest experience of feeling is religion and art. Nature is the goal—but that is where God is, and I feel Him, strongly, very strongly, more strongly yet. I do not believe that modern art exists; there is only one art, it is eternal.

Self-portrait

I exist for myself, and for those to whom my unquenchable thirst for freedom gives everything, but also for everyone, since insofar as I am able to love—I love everyone. Of noble hearts, I am the noblest—and the most generous of those that yearn to give love in return.—I am a human being, I love death and I love life.

Anarchist

At the place where something great began, the world resembled it in its unity. God was alone, alone in his absolute solitude. I ran to that place, I felt his presence, breathed in his smell. Such are you—ear, wind, mouth, such for you is the only thing that exists: form. Oh whistle, shrieking Circe, stretch out your legs into the distance. The tempest moans, and calls! Call, you, oh call! Without the All, without struggle, caress like the air. Raise up mountains, hurry here with evil-tasting drinks.

Portrait of the Pale, Silent Girl

A pollution of my love—yes, I loved everything. The girl came along, I discovered her face, her subconscious, her working girl's hands, I loved everything about her. I had to paint her, because she was looking at me and was so close to me.—Now she has gone. Now I have nothing left but her body.

The White Swan

Over the lake in the park with its odors of moss and fringe of black glides the tall, round swan, in an iridescent foam.

Cornfield

The wrinkled earth is bathed in a luminous radiance. With their regular breathing, suns heat up the fertile soils. Patches of yellow come in violent contrast to break up the dense saturation of green; as they move closer they grow, and we see yellow atoms that are dancing in a joyful hymn to life.

Damp Evening

I wanted to look out for the fresh breath of the evening, the black trees that foretell the weather, I say: the black trees that foretell the weather—and then I wanted to catch the sound of the mosquitoes, the doleful, heavy tread of peasants, the bells ringing in the distance, the trees racing along the river; I watched the avenues lined with trees that seemed to speed by in a flash, and I lent my ear to mosquitoes' song, so close to that of the telegraph cables in the windy winter landscape. But the tall black man broke the sound of their wires. The neat, orderly town was cold in the water, there in front of me.

Fir Forest

I penetrate the glowing darkness of the vault of firs, it lives without sound, and gazes at itself in silence, like a mime artist. The ocellated trunks cling on to each other, and exhale a palpable breath, laden with moisture.

How lovely it is here! Everything, even what is living, is only dead.

SKETCHES

Taken from a book of sketches by Schiele, A Painter Gives Us His Sketches, *these poems were published in the artist's lifetime in* Die Aktion *(Berlin).*

Lady in the Park

. . . So I shall keep walking along this path whitened by the sun—I who was red.
I saw the lady, all blue amid this green—in the green garden.
She stopped, and stood still—she looked at me with her round black eyes. She had a face that was almost white.

Two Ecclesiastics

The field of green-gray and orange grass covers
the round, rolling clod, in gleaming black satin
with his great brown-red head,
on which the lenses of spectacles glitter in the sun.
The cross hanging from the white chain bobs up and down.
Striding along beside him is the
tall man, pale, gray and grumpy,
eyeing you surreptitiously over his glasses,
then moving away, muttering, into the free air of the country.

Country Road

The tall trees were on parade all along
the road.
The hopping birds were chirping in the
branches.
With long strides and eyes reddened by
illness,
I walked up and down the rain-sodden
roads.

Approach of the Storm

Heavy, black, bad-weather clouds were
rolling from all sides into the hills—
Woods laden with water giving the
alarm—
Droning huts and humming trees—
I head for the black-water stream—
birds looking like pale leaves in the
wind.

Music for a Drowning

There were moments when the black
stream overwhelmed me entirely.
It seemed to me then that this meager
river, and its soft, high, steep banks,
were immense.
As I struggled and writhed about, I
could hear the waters within me,
the warm, beautiful, blackish waters—
Then the pure gold of energy gave me
back courage and strength.
The current gushed forth, impassive and
ever more violent.

Visions, 1914

I was in love with everything—
I wanted to look with love at the angry
people,
so that they would be forced to look
politely back;
I wanted to offer gifts to the envious,
and tell them
that I am worthless.
. . . I could hear soft winds passing
through the rays of air.
And the girl reading in a plaintive voice,
and the children staring at me with their
large eyes and answering my gaze
with caresses,
and the distant clouds,
they were looking at me with kindly,
creased-up eyes.
The pale, white girls showed me
their black legs and their red garters,
and spoke to me with black fingers.
Meanwhile I was dreaming of vast, far-
off worlds, of the fingers of flowers—
I scarcely knew if it was really I who was
there.
I saw the park: yellow-green, green-blue,
green-red, green-violet, sun green,
vibrant green—
And I listened to the blossom on the
orange trees.
Then, I tied myself to the wall of the
oval park, and listened to the children
with tiny feet; the children speckled
with blue, and striped in gray with
pink flakes.
Over there the columns of the trunks
traced precise lines, when they lay
down beneath in a sensually coiled
pose.
I thought of my colored visionary
portraits
And it seemed to me that with all of
them I had spoken only one single
time.

from *Tout l'oeuvre peint de Schiele*,
Flammarion, 1983

Correspondence

A large body of Schiele's correspondence is conserved at the Albertina in Vienna. It consists of personal messages to his family, letters to gallery owners and collectors, love letters, and even short notes asking for money. In it we learn about his psychology and lifestyle, and about the artistic milieu of his time. In letters to people he trusted he made some all-too-rare attempts to explain his work, which provide keys to its interpretation while at the same time raising further questions about it.

To his friend Anton Peschka

[Before May 12, 1910, Vienna] Peschka! I want to get away from here, as quickly as possible. Everything here is so odious. Everyone is envious and deceitful; former friends walk past me with sly looks. In Vienna there is nothing but shadow, the city is black, everything is shallow and rule-bound. I want to be alone. I want to get back to the Bohemian forest. May, June, July, August, September, October; I want to see and work again, I want to see new things and I will look for them. I want to taste the dark water and see the trees creaking in the wild wind, I want to look in astonishment at the decaying garden hedges, to see how all of that lives, and listen to the copses of young birch trees and their rustling leaves; I want to see the light and the sun, to savor the damp valleys of the evening when green is turning to blue, to catch the fleeting brilliance of golden fish, to see white clouds forming; I want to talk to the flowers, to peer closely at blades of grass and pink-skinned men, to talk about venerable old churches and small chapels, I want to walk endlessly over verdant hills and vast plains, I want to kiss the earth, to breathe in the warm, tender flowers of mosses. Then, I will give form to beautiful things: fields of colors. . . .

At dawn I would like once more to see the sun rise, to be free to watch the earth breathe in the vibrant light.

To harmonize fields that breathe joy and beauty with the perfumed air of roses. The padded curves of misty, rugged mountains on vast, distant horizons. . . . Oh you, odorous earth, before us, under me, awaken me, make me ripen like a fruit in the sun! You, dark, brown, dusty earth, with your sweet-smelling dew, perfumed with flowers, drawing in fragrances: open yourself out to the sun which gives us everything. Joy! Light beyond price, shine forth!

Get to work, active man! Be an inexhaustible river. You, green valley, you look at me, and you are filled with a green, watery atmosphere. From my half-closed eyes I weep great red tears,

whenever I have the joy of seeing you. You, sorrowful eye, you feel the damp breath of the forest. You who are assailed by fragrances, with what rapture must you breathe in the divine breath!

I laugh as I weep, friend; better than that, you are in me.

Now I am lying down amid the living moss that speaks, yellow flowers, clear and pure; waters that breathe and speak of life . . .

And up above, how great the world is! Let me too become enraptured, and lose this prosaic earth from sight.

I am asleep.

All the mosses are coming to mingle their rippling, caressing life with mine. All the flowers are trying to see me, and making my trembling senses vibrate. Green oxide buds and delicate poisonous corollas uplift me. I float in space, indifferent . . . how strange the world is. Then, I dream of savage, tumultuous hunts, of red, pointed toadstools, of great black cubes which shrink and disappear then, as if by a miracle, start to grow again and turn into huge giants; I dream of fires with a hellish glow, of a battle between far-off, unknown stars, of eternal, gray eyes, of Titans struck down, of a thousand hands creasing up like faces, of boiling clouds of fire, of millions of eyes that look at me benevolently and grow whiter and whiter, until I can hear.

E. S.

To Gertrud Schiele

[Krumau, August 25, 1910]
Last night I had a beautiful spiritualist experience, I was awake and yet in the grip of the spirit that had appeared to me in my dream. All the time he was speaking to me, I could not move or speak.

E. S.

On the back of the card, a slightly different version of this event was added by Anton Peschka, a friend of Schiele's from the Academy of Fine Arts who was courting Gertrud at the time.

Dear Miss Gerti, Egon is here again and is working extremely hard He is drawing all the beautiful girls . . . I have met here, and enjoys conversing with them. For the moment, he is looking for a large room where he could paint large-format portraits . . . I like Krumau more and more . . . they are very nice to us, which is encouraging us to stay a while longer! How are you, are you still busy in Vienna? Are you still alive? We have heard nothing from you. Egon still talks in his sleep. Yesterday evening he told me that his papa had come to visit him and that it was not a dream, he really did talk to him.

A. P.

To Oskar Reichel, doctor and collector

[After November 5, 1910]
Dear, dear Doctor Reichel, Here I am, completely penniless. Just now I have had to pay out nearly 300 krone; I beg you, bring me 20 krone tomorrow morning, Saturday, please, I need the money so badly, otherwise I will have nothing to eat. So for pity's sake, be so kind and take the trouble to come and see me at home tomorrow, won't you? You can have anything from me that you want.

Take the train to Nussforderstrasse, and in 15 or 20 minutes you will be in Schönbrunn, come, I beg you! I will wait for you until midday.

Regards.
E. S.

Letter from Arthur Roessler to Egon Schiele

[January, 4 1911]

Dear Schiele—things between us need to be sorted out. Following various recent events, and your strangely ill-mannered behavior toward me (for example your obstinacy, and a correspondence in which you have shared my secrets behind my back with third parties and gossips), I feel obliged to bring to your attention that I have made the following payments:

1. For the production of reproducible copies based on plates which you have given me: 22 K.

2. For a delivery of 18 postcards as well as copies: 90 K.

3. For Japanese paper: 25 K.

4. For the frame, easel and various supplies: 12 K.

5. For my portrait and some other works, paid for by me in person: 265 K.

Thus a total of 414 krone.

In addition, thanks to my interventions you received 200 K from Dr. Rainer and 100 from Dr. Reichel for "Self-seer." Subsequently, my efforts on your behalf earned you a total of 100 K from Kosmack, Rosenbaum and Schöntal, and Dr. Reichel (who asked you to paint his portrait following my pressing exhortations) paid you about 500 K for that and various other pieces, which means that since October, thanks to my efforts you have received a total of very nearly 2,000 K, almost a quarter of which were paid by me alone.

You will find all of this perfectly normal—and so do I; but I have felt obliged to remind myself of the aforementioned facts concerning you, because I do not want to run the risk of even worse malicious gossip—in which you, as I learned the day before yesterday, have a regrettable tendency to indulge. I do not know in what terms or in what tone you have spoken about me—and essentially I do not care, I have better things to do than concern myself with idle gossip—but I know that you cannot hold your tongue, that is to say that you are driven by an infantile need for recognition to repeat to others what I have told you, in the belief that I could trust in your discretion. What I have done for you I have done of my own free will, and I am not sorry to have done it; I also think that you have no reason to doubt that the help I have given you has been completely disinterested. As a painter you interest me as much as ever; I shall continue to follow up your invitations to come and see your new work and to purchase your works, insofar as my financial situation and your prices permit. Nevertheless—and this is imposed on me by caution and by my desire for calm and decency—our relationship will have to be more distant until you have begun to acquire the more gentlemanly manners that one would wish to see, and to show as much intellect and culture in them as there is art in your work. You should also spend less time gossiping about your relationship with Klimt, and instead think now and again about re-examining your behavior toward the Consultant to the Wagner Building, and not tastelessly offend a man who is friendly and kindly disposed toward you. Bluff on its own is not enough, believe me.

Yours,
A. R.

Schiele's reply to Arthur Roessler

[January 6, 1911]

I, the eternal child—I followed in the path of people driven by passion, and did not want to be one of them, I said;

whether or not I spoke, I was listening and had a strong or even stronger desire to hear, and see.

I, the eternal child—I made sacrifices to others, to those who inspired compassion in me, to the far-off ones who could not see me Seeing them. I brought them offerings, I directed their gaze beyond the wavering, tremulous air, I opened up roads for them that they could walk on—and I did not speak. There were some who recognized the inner vision in a language of signs, and from then on asked no more of me.

I, the eternal child—I cursed money from the start and I laughed, and at the same time I wept as I accepted them all: tradition, the need for funds, cash convertible assets, an assigned inheritance. I saw money as nickel, nickel as gold and silver and nickel, and the whole of it as unreliable and of no value or interest to me, although the assigned inheritance makes me laugh, and cry; where is it leading me? Where? Some say that money is food. Some say that money is possessions. Others say that money is life. But who tells you that the gold is you yourself?—Goods? Possessions, wealth—Oh—living beings full of life—Who are the living?

No bargaining. All States ensure that the living are few and far between. —Be yourself!—Be yourself!

Where the "ex-libris" begins, there begins the life of the living—where the "schoolboys" begin, there live the dead. Living?—Living is spurting out seed, spreading it, wasting it, and for whom? For other poor people perhaps, for the eternal schoolboy, oh the eternal schoolboy, oh the eternal uniform, oh the eternal State; many complaints are made against people whose bodies are living; those who make them are the public, the people, the masses, the soldiers, the civil servants, the teachers, the non-indispensable ones, the craftsmen, the conformists, the citizens, the patriots, the judges, the bookkeepers, the men of rank, the accountants.

Where is the difference? It is between those who do and those who do not do. Bluff is already an act when it is invented. The word is not a specific act, at best it is a dead act. Where do words go?

The artist is he who expresses himself. The living being is unique. Buy! Not images, not goods, not work. Images? They are not by me, they are me. Buy me.

<div align="right">E. S.</div>

To Oskar Reichel

[June 20, 1911]

Dear Dr. O. R. Sooner or later people will start to believe in my paintings and writings, and have faith in my words, which are rare but so very concentrated. Perhaps my paintings so far are nothing more than preludes, I can't tell; I am so dissatisfied with them, from first to last. Those who think that painting is something in its own right are wrong. Painting is never anything other than a matter of technique: you can do it, or you can't, that is all. I dream of the union of the warmest colors, ones that flow, spill over, break apart, jut out, with sienna applied irregularly over greens and grays, and close by a star of cold, white azure or blue that borders on white. I have become initiated and I have done my calculations, have observed one enigma after another and tried to apprehend it. The painter can also look, but seeing is something more. To make contact with the image that enthralls us is a great deal to ask. The will of the artist?

<div align="right">E. S.</div>

[September 1911, Neulengbach]
Dear Dr. O. R.! I have become a visionary; the earth breathes, smells, hears, perceives in all its smallest parts; it grows, breeds, decays, and rediscovers itself, savors what life is and seeks the logical philosophy of everything, of the all in all; the days and years, all transience as far as one is willing and able to think, as far away as the Spirit of beings of great substance; in passing through our air and our light it has become something or a great deal, a creature that is necessary to itself; it is partly dead, consumed within itself, and once again—back in itself the small or great cycle begins, everything that I would like to call divine—it germinates and creates a creature from forces that few can see. In the sense of Being-there, matter is bound to be continuous; by living one must understand a continual disintegration, which tends by organic means toward restoration, so that for matter there can never be a total death in the full sense of the word. It was, is, and will be the old or new Spirit of origins that wants to and must bring some kind of encounter, of mixing, and carry it through to birth. The true grandmother of everything, the same as everything despite the individualization that determines and thus was, is and always will be the pattern for these, our infinite powers; multiple humanity, beasts, plants, living beings in general can be created wherever this matter exists, wherever there exists the communal will of the world. I have within me the immediate faculty of being able to draw in order to set down in writing, of wanting to search in order to invent and discover by my own powers, which are already highly developed; to blaze and consume myself and shine like a thought of eternal light,

to shine in the dark eternity of our little world, which contains only so very few elements. All our protective covers are worth nothing to us, they hide us instead of inspiring in us the need to interweave ourselves with other organs. When I see the whole of myself, I must also see what I am, know what I want and not just what is at work within me, but also how much capacity I have for discerning what my powers are, those enigmatic substances of which I am made up, and what is more how many of them there are; all of this I recognize from what I have already recognized before now. I see myself evaporating, but even so I breathe more and more strongly, the vibrations of my astral light are gaining speed and becoming more direct, more simple, like those of a great initiate of the world. Thus I give ever more, and ever further, an endless illumination of myself, inasmuch as Love, which is everything, gives me the power to go toward that to which I am instinctively drawn, gives me the power to pull out of myself what I need to give something more that is new—a fact that, despite myself, I have contemplated. My essence and my decay, transposed into residual values, must sooner or later give my strength to other educated or very highly educated people, like a revealed religion. Even those who are furthest away will take heed of me, and live under my hypnosis. I am so rich that I must offer myself at all times.

E. S.

To his uncle and guardian, Leopold Czihaczek

[September 1, 1911]
Everything that I have produced in the last two or three years, be it painting, drawing, or writing, is intended to "open up the future." Until now I have done

nothing other than give, and I feel so enriched by it that I have no choice but to go on making a gift of myself. If the artist loves his work above all else, he must be capable of letting down even his best friend. Why have I stayed away from you? There are some, I know, who give an unfair answer to this question, and you must think that I am being difficult. The truth is that I am trying to resist all the stresses and strains of life. I aspire to know everything by experience, and to do that I must be alone, I have no right to let myself go soft, I must be hard and allow myself to be guided by thought alone.— I have already achieved various things; for instance, some of my paintings are on show at the Folkwang Museum at Hagen in Westphalia, and at the Cassirer gallery in Berlin, etc., which I may say leaves me cold.—I know that I have made enormous progress artistically, I have had a thousand enriching experiences, and have struggled relentlessly against "commercial" art. . . . The little that I have learned about psychology in my contact with "reality" enables me to say this: small-minded people are vain, and too small-minded to be capable of pride, and great people are too great to be capable of vanity. . . . The most precious thing in my view is my own greatness.—Here are some aphorisms of my own invention;

As long as the elements exist, there can be no absolute death.

Anyone who is not hungry for art is close to decrepitude.

Only people of limited intelligence laugh at the effect produced by a work of art.

Point your gaze into the inside of a work of art, if you are capable of doing so.

A work of art has no price; it can be bought, however.

It is certain that deep down, the Great men were good men.

I am pleased to say that people with a sense of art are rare. This is a constant sign of the presence of the divine in art.

Artists will live for ever.

I know that there is no modern art, but only one art—which is eternal.

If someone asks to have a work of art explained to him, there is no point in granting his wish; he is too limited to understand.

I paint the light that emanates from all bodies.

The erotic work of art has a sacred character too!

I shall go so far that people will be seized with terror at the sight of each of my works of "living" art.

The true art lover must aspire to own both the oldest work of art and the most modern one.

A single work of "living" art is enough to ensure the artist's immortality.

Artists are so rich that they must give themselves at all times, without respite.

Art cannot be utilitarian.

My paintings will have to be hung in edifices that look like temples.

E. S.

To Carl von Reininghaus, collector

[February 13, 1913]
The most eminent of men and the greatest of artists do not count for as much in my eyes as that pure, sublime, and very noble Man (Christ).—I came into the world by the grace of love, I live with love for my fellow men of every kind, and it is also by love that I would like to leave this world.—I know that there is only one in a thousand who lives with love in his heart for men, animals, plants and things, I know that only one in a thousand sees the living organization of all things, or is capable of perceiving the living breath of a plant's face in its spiritual life and appearance. . . .

No man has ever brought me joy, everyone holds a grudge against me more or less; I endeavor to look deep into the hearts of those whom I respect, but I have found nothing significant there. . . . In any case, I shall remain true, and faithful to myself, even if it means that the most precious treasures escape me. That is why I hate businessmen; I meet them endlessly on my path, those liars! When someone speaks ill of me, it is always a jealous painter, or a critic who spends his time studying art history, or some conformist. . . . There are some who accompany me on my way, firmly determined to follow new paths, safe from the objections of others—they think!

E. S.

To Franz Hauer, collector

[August 1912]
At the moment I am mainly observing the body movement of mountains, water, trees, and flowers. Everywhere there are reminders of movements in the human body, which are similar to the rushes of joy and pain in plants. Painting alone is not enough for me; I know that it is possible to create intrinsic qualities with colors.—In the secret places of the heart it is possible to imagine an autumnal tree in the middle of summer; it is that melancholy that I would like to paint . . .

[January 25, 1913]
When I was nineteen, I made myself independent. I had to overcome numerous obstacles, more perhaps than anyone else . . . and a reflection of these can be found in my work.—My colleagues were all my enemies; I began to hate Vienna, and wanted to live alone in Krumau, but that was impossible, because I had no money.—I needed Vienna; nevertheless I went to Neulengbach in order to find solitude there, while at the same time being very close to Vienna.—I became a man! It so happened that a young girl fell in love with me, and had no compunction about coming to see me at my house. I sent her away, but she came back the following evening, and refused to leave. There was no one in the neighborhood who could come and fetch her.—And if I had called for someone I would almost certainly have created a tremendous drama. So I let her stay with me, and wrote to her parents.—Her father came to pick her up.—She was checked to make sure that she had not been touched, but even so the affair ended up in court.—And then the thanks I got for my kind-heartedness was to be humiliated in the most infamous manner. I lost all confidence in people who were otherwise entirely respectable. That was a dark, oppressive time for me; I discovered all the vileness that can ooze out of the human being, but I also met many men who were genuine and misunderstood. No one close to me lifted a finger, except Wally [Wally Neuzil was a model of Klimt's, who then became Schiele's companion from 1911 to 1915, when he married Edith Harms]; I had known her for a short time, and she behaved with a nobility of heart that enchanted me.

I can recognize people with a generous heart, and I realized how pure hers was, and began to meditate on the breed of liars and wicked men. It occurred to me then that the true, authentic human being is destined to live for ever. I was filled with disgust for that melancholy landscape around Neulengbach, once so dear to my heart, and decided instead to go to the region near the border. I spent the year of 1912

in Bregenz, looking at the endlessly choppy water in the lake, and the distant, snowy mountain tops of Switzerland.—I wanted to start a new life, but have not had the possibility of doing so until now.—Nothing in my life so far has been a success.—I dream of finding myself among free men.—I love Austria so much; and I miss it.

To Anton Peschka

[March 2, 1917]
And now, listen; we have met again—"Kunsthalle"—everything is moving ahead with giant steps and in grand style.—It was in the air.—Figurative art, literature, and music. The artistic world in Austria is ready for action. The founders are artists and art lovers. They include Arnold Schönberg, Gustav Klimt, Josef Hoffmann, Anton Hanak, Peter Altenberg, and many others, the best art historians, etc. It is not an association, just working groups. This is the appeal we sent out: "Since the bloody horror of the war came crashing down on us, many have realized that art is much more than a bourgeois luxury. We know that the return of peacetime, which is now so close, will give free rein to the great debate between the materialist tendencies of our civilization, and those remains of our culture that the mercantile age has allowed to survive until our time. In such a situation, all intellectuals have a duty to prevent our Austrian cultural heritage from disappearing, and to promote the realization of plans made by a younger generation that is determined to build something new, and to break at all costs with the chaos of the past. We must prepare to fight for those who will be coming back from the war; it is important that they find the possibility of creating in purity, and working for the common spiritual good. It is therefore essential to safeguard the rising generation against isolation, and ensure that it is not cut off from real life. With this aim in view, independent young people have grouped together to create an intellectual meeting place; they have rented an exhibition and lecture hall that will be opened to painters, sculptors, architects, musicians and poets, and will also give them the opportunity to have contact with that section of the public that wishes to defend itself against the threat of cultural disintegration.

. . . Our initiative does not spring from an ephemeral whim, it is an action that is both moral and patriotic. That being the case, anyone who did not take part would cause irreparable damage to the spiritual life of Austria. . . . We are at a turning point in history; conscious of the exceptional nature of this moment, we consider it our duty as men to prove that we have not remained indifferent when it is a question of protecting and saving what is most noble in the world—a cultural heritage that goes back down the centuries—and that it was up to us to bear witness and sacrifice ourselves for the spirit.

We are under no illusions about the size of our undertaking, and the difficulty of carrying it out; but it is with joy and enthusiasm that we face up to this apparently impossible task, because we are young, and because we are doing it for our country."

Letters conserved at the Albertina, Vienna.

Egon Schiele in Prison

Published in 1922 by Schiele's earliest critic, Arthur Roessler, Egon Schiele in Prison *contributed more than any other work to the image of the artist as a martyr and a victim of the incomprehension and rigidity of his time. Recent research is in agreement that the text, containing word-for-word commentaries on the drawings executed in prison, was in fact written by Roessler himself. In the light of this, the work can be seen as an interesting insight into the birth of the artist's legend.*

April 16, 1912

At last!—At last!—At last!—here is something that will do a little to relieve my suffering! At last I have paper, pencils, brushes, and paints with which I can write and draw. What a torment those gray-gray, monotonous, shapeless hours were, all exactly the same, crude, confused, and empty, which I was obliged to spend naked, stripped of everything, like an animal, between these cold, bare walls!

Anyone with less inner strength than I would have gone crazy right away, and so would I in the end, from being numb with boredom day after day; and so in order to avoid really going crazy, having been brutally uprooted from the fertile soil of creativity, I started to moisten a trembling finger with my bitter saliva and use dirty patches in the mortar to paint landscapes and heads on the walls of the cell; then I watched how they gradually dried, grew paler, and disappeared in the depths of the walls, as if erased by an invisible, powerful and magical hand.

Fortunately I now have drawing and writing materials again; they have even given me back the dangerous little penknife. I am able to work, and thus endure what would otherwise be unendurable. For this to happen I had to go on bended knee, I belittled myself, I made an official request, I begged, pleaded, and would have burst into tears if necessary—Oh all-powerful Art— what would I not be capable of enduring for your sake?

April 17, 1912

The 13th.—The 13th.—The 13th.— Thirteen times the thirteenth of April! Before now, the number thirteen never inspired any superstitious fear in me, whereas now the thirteenth day of the month has turned into a day of disaster. It was on April 13, 1912 that I was arrested and put under lock and key by the district court in Neulengbach.

Why? Why? Why?

I do not know—I have received no answer to my question. . . . In hell! No, not Hell with a capital "H." The hell I

was unceremoniously thrown into is a very precise, vile, abject, filthy, miserable, humiliating one.

The dingy, crumbling mortar is spattered with dust, spiders' webs, gobs of spit, sweat marks, and tears as well. Where the bed touches the wall the stains are worst, and the coating of whitewash is worn away, revealing pieces of blood-red brick that are completely smooth and have a greasy shine, as if they had been polished. I now know what a dungeon is—the whole place looks like an oubliette. . . .

Only the push-button for the electric bell at the head of the bed stands out from this scene as a sign of modern times. And that is why I know that I am not dreaming, that I am not falling prey to visions. No, I am not dreaming, I am alive and suffering—unless life itself is nothing but a dream in which nightmares hold sway.

April 24, 1912

No distance at all from me, so close that he would hear my voice if I shouted, is a man sitting in his courtroom who is a judge or something like that, a man anyway, who thinks he is better than other people, who has studied, who has lived in the city, been to churches and museums, theaters and concerts, and even, no doubt, art exhibitions, who can therefore be regarded as a cultivated person, who has read or at least heard of artists' biographies—and this man can bear the fact that I am shut away in a cage! He leaves me to rot here for hours and days, and shows no concern for me at all. What is he thinking of?—Does the man have no conscience? . . .

April 27, 1912

What would I be doing now if I did not have art?—How terrible those bewildering hours were—brutally torn away from infinite dreams in which there is nothing ugly, only astonishing things, and feeling oneself being violently dragged into an absurd, brutish, primitive state that lacks anything that could make it beautiful by exerting energy and strength.

I love life. I love to immerse myself in the depths of all living beings; but I abhor this compulsive, hostile "you must" that holds me captive, and wants to force me to live a life that is not mine—a low, functional, useful life, without Art—without God.

Vienna, May 8, 1912

24 days of incarceration!—Twenty-four days or five hundred and seventy-six hours!—An eternity! The trial was conducted appallingly—but for me, the misery I suffered was indescribable. . . .

During the court hearing, one of my confiscated drawings, the one that was hanging in my bedroom, was solemnly burned in a candle flame by the judge in his robe!—Auto-da-fé! Savonarola! Inquisition! Middle Ages! Institutionalized castration, hypocrisy! You may as well run into museums and carve up the best works of art. Anyone who disavows sex is unclean, and in the vilest fashion sullies the parents who gave him life.

From this time on, all those who have not suffered as I have should feel shame in my presence!

Extracts from
Egon Schiele in Prison

Critical Reception

Discovered by Arthur Roessler in 1911, Egon Schiele attracted critical attention first in Austria and then in Germany, before being rediscovered after World War II in the United States, where many Austrians had taken refuge. There were exhibitions of his work in the 1980s, when he was initially viewed as one of the Viennese trinity of Klimt, Schiele, and Kokoschka. Today, however, he tends to be regarded as a separate figure, out on his own as the master of Austrian expressionism.

A Being Set Apart

. . . It is an indisputable fact: . . . Schiele's paintings have almost nothing of that "refinement of execution" and true naturalism that are so highly prized, they have no moralizing tendency, and do not aim to be objectively charming; on the contrary, they are irrational, and have nothing to do with any utilitarian preoccupation. Neither the bourgeoisie nor the aristocracy will feel any emotion at the sight of Schiele's figurative works, they will not speak to their hearts, still less to their minds; they will barely even appeal to their senses, since Schiele stands outside society, he is a solitary . . . He does not shrink back in terror at the sight of the horrors that we can all encounter, but he is repelled by convention and, being congenitally incapable of yielding to compromise, he rejects outright any concession that could strike a blow at art, and any hypocritical attempt to win him over. It would be a mistake in his eyes to meet the public halfway; he believes that it is up to the public to come and meet him. . . .

Schiele is one on his own. His paintings convey to perfection nervous sensations that are oriented toward sensuality, impressions that are full of sensibility. Their origin was and continues to be an inner impulse and need, they are free of any posturing or grandiloquence; entirely devoid of hope, they appeal only to those who can still see genuine, irreplaceable values in the sensual experience of secret moments in our lives, in their simplicity, and in their transposition to the canvas. . . .

As for those who can see nothing other than the nude, and the obscene nude, in Schiele's works, too bad for them, since "the sensibility of every human being is a component of his nature."

Arthur Roessler, "Egon Schiele," in *Bildende Künstler, Monatsschrift für Künstler und Kunstfreunde,* March 1911

An Inlay of Amber

In any case, what we find here responds amply to our need for modernity. Egon Schiele's cruelly fantastical caricatures are ghostly lemurs with bleeding, spiderlike fingers, mutilated or half-decayed corpses which look as if they are being viewed in a distorting mirror; the paintings themselves appear to have been exhumed from ancient tombs: colors that have blackened or turned pale over time on walls with half-ruined surfaces, or on some crumpled, yellowed piece of parchment; then here and there, a sort of inlay of amber, lapis lazuli, chrysoprase and other precious stones, with a primitive charm and a sense that it is about to fall apart. In these grotesque representations, a refined, playful virtuosity is expressed in the drawing, with a rare sureness of taste for color, and a keen sense of charm in the execution.

F. Seligmann, review of the Hagenbund exhibition, *Neue Presse*, April 13, 1912

Mastery in His Drawing

With this extensive collection of drawings and paintings, some of them in large format, Schiele confirms our previous judgment of him. He has by far the strongest talent and the surest technique of the painters of the extreme avant-garde; often truly masterful in his drawing, and a colorist of refined taste, he is equally outstanding technically, in his treatment of the surface and pictorial touch. In addition he has a strong personality, alas only too strong. His subjectivity veers toward mannerism, in the bad sense of the word; his excessive characterization degenerates into a grimace, and the whole impression is of a pathological turn of mind so pronounced that it may be of more interest to the psychoanalyst than to the art lover. . . . We will therefore respond to his "confessions" with mixed feelings. Along with the admiration they arouse for his artistic qualities comes a sense of horror at the mud that rises from them, coming from the darkest and most secret depths of a fevered soul. Never have such lubricity and corruption, distilled in the pure state without any diluting ingredient, been painted with such genuine artistic power and, one might say, in such a classical manner.

F. Seligmann, comment on an exhibition of modern art at the Arnot Gallery, in *Neue Freie Presse*, January 8, 1915

The Change Had Been Accomplished

Schiele is one of those artists whom no one liked or judged fairly at the time when his face appeared, like something unreal from a world that had never been seen before. And yet it was not always like that. The Wiener Werkstätte (W.W.) had been gradually accepted in wider circles, so much so that a few moments of benevolent attention were granted to some paintings by this very young artist that were shown at the Kunstschau, after which people thought they had done justice to the subtle colors and forms chosen by a zealous epigone of Klimt. Even Muther did not try to understand him better, and later no one would understand the process of transformation that these charming colors were to

undergo, because they faded and became more and more pallid and unreal, while at the same time he showed the bulging skulls of sickly beings and stiff ascetics ringed by greenish, bluish, rust-red or fiery red veins. People must have felt that it was completely incomprehensible—because the charming preconceptions of the W.W. were no longer of any help. What determined these colors had nothing to do with adapting to a black and white interior space with gleaming display cabinets; it was a spirituality that broke through the carapace and produced the kind of lines that are defined as "stiff" and "bulging." Ah, the line! It claims it birthright, and when I imagine the paintings of that time, the "generation," those austere, red nudes, the portraits, and many other works by this prolific artist being born before my eyes, the line stands out as the prime element in the whiteness of a background as vast as a fresco. The change had been accomplished. . . .

No one realized then to what extent the color was given by life and by the homogeneity of the graphics. How it slipped in gradually, like a vague patch of fog, between the implacable black verticals, introducing a promising, reddish glow around the concentric arches of the eyebrows, heaping up in triangles and florid squares to form a draped image that was forced to play here, then slide and accumulate there, because thought, emerging from a dark hiding place to push toward a definitive version, dictated that it should be so, and used the drawn line as a means of communicating its will to the color.

Otto Benesch,
from the preface of *Egon Schiele,*
exh. cat., Arnot Gallery,
Vienna, January 1915

One of the Most Captivating Representatives of Modern Art

The slow process of disintegration of our cultural ideals has given rise to a determination in the artistic community to regroup our last forces once again, in order to discover answers to questions which hang eternally in suspense. There is something violent and tense in this type of art. . . . Turning its back on the intellectualism of the Renaissance, this movement has a close affinity with the spirit of Gothic, which looked for mystical connections between our deepest intimate experiences and the outside world, and between the formal language of art and its means of expression. . . . Schiele is undoubtedly one of the most captivating of these young representatives of modern art, for whom visible form is the symbol of an inner reality, and for whom the relationship of objects within the artistic space illustrates correlations of a metaphysical order. Egon Schiele has produced remarkable things, both in painting and drawing. What is exceptional about his talent is that he has been granted the gift of vision in both the pictorial and the linear fields. This is clearly evident in his graphic work; alongside black and white drawings with a strong use of line, it also includes works which break down the barrier between painting and drawing, and with their remarkable chromatic effects create a radically new type of art.

It is not just the technical aspects of his work, however, that deserve attention. In addition to his sense of color and line, and his almost unparalleled soundness of judgment

in the use of space, what most merits our interest in his work is the value of the spiritual confession that it contains. There are few modern artists who have been able to give such forceful expression to the greatness of sexual life, but also to its disquieting aspects and elements of vampirism. For him, the woman is a restful being, as if in her aesthetic values she were rooted in a naïve equilibrium; the man, on the other hand, has mastered and at the same time refined his own instinctual life. The men in Schiele's work have something disturbing about them. They are both anchorites and vampires, sensual and cerebral beings. For him, however, the "Gothic" is not a formal external element, but rather the sum of experiences lived, in the opaque depths of the human psyche, by a spiritual being torn between the two extreme poles of his earthly nature. This medieval element, with its terrors and secret pleasures, repentances and celestial illumination . . . gives form to the only mode of expression that is still conceivable in our time.

U. Brendel [L. Lieger],
in *Die Aktion*,
June 1916

An Art That Never Shows a Smile

Schiele in Vienna is unquestionably a great artist, full of vigor and an extraordinary virility. . . . His art—an authentic art if ever there was one!—never shows a smile; it accosts us with a horrible grimace which sends shivers down the spine. In one sense, this Egon Schiele is a moralist whose painting is full of menace. The vision of vice that

he give us in his works has nothing attractive about it, and certainly nothing seductive. He revels in an orgy of colors—the colors of putrefaction. . . . There are many paintings, which are remarkable for their depth of penetration. A number of his portraits, however, also show astonishing insight and force in their rendering of character. They mercilessly uncover the abysses of the human psyche, which they deny and destroy. His remarkable landscapes are breathtaking achievements in terms of beauty and effectiveness. . . . It should be said again that what places Schiele head and shoulders above all other artists is the quality of his drawing.

A. Friedmann,
in *Wiener Abendpost*,
March 1918

The Anguish of Living That Murmured within Him

The young Schiele wanted to paint the most everyday human things: *Weltwehmut* (Melancholy), *Deliren* (Deliriums), *Tote Stadt* (Dead City), *Der Lyriker* (The Poet), *Der Selbstscher* (Self-portrait: Self-seer), prophets and hermits were among the subjects he dealt with. There was something desperate about the world that presented itself to him. His figures writhed in a passionate agitation which broke limbs and distorted bodies; it was only when they were freed from the deceptive outer coating of conventional beauty that they could express the deep distress of the artist who gave them life. The public, with its preference for naturalism, was frightened by what was thus revealed; it saw human

beings reduced to the state of skeletons, men flayed alive, apparitions from hospitals or mental asylums, where the artist went to look for mediators who would not provide the public with reassuring images from which they could look away in blasé indifference, but would express the melancholy and anguish of living that murmured within him. That was why their faces had to be dehumanized or humanized in order to capture a single sensation, as if in a mask; that was why their emaciated bodies, elongated limbs, and spiderlike fingers acquired an expressiveness that surpassed any naturalist criteria. His colors do not attempt to reproduce any sort of reality; the bright spots and pale flat patches emerge from the darkness of the night that envelops them on all sides, and divide themselves up in accordance with their own impulse over the whole surface of the painting.

Not all the paintings from this period are marked by this sorrowful despair; in the natural course that feelings take, it resolves into a moving compassion for others, which can be seen in the portraits of children and landscapes which also form part of the young Schiele's work. During this period of youthful overexcitement he, like many passionate natures who are soothed by the contemplation of children, was constantly in search of the innocence of childhood. What attracted him most was the child who was most deprived of love, the poorest and sickest, dressed in rags and dying of hunger. He had a rare talent for understanding the defenseless grace and timid reserve of childhood; with his knowledge of the adult world and his terror of it, he abandoned himself to the world of the child with all the nostalgia of a temperament thirsting for love. His early landscapes are similarly impregnated with feeling. Schiele did not seek out nature in a state of beauty, when the onlooker is moved by its grandeur and grace; he liked it denuded and sad, as it is in early spring or autumn, or sparse, as on the outskirts of a big city; he empathized with bare bushes raising their leafless branches to the sky, with earth that had just been turned over by the plow, with small wisps of passing cloud. All of that came to life for him and became silent distress, deep despair or weary resignation. But at the same time as he drew on his intense feeling of life to restore a soul to what appeared to be dead, his drawing exalted the charm of the line, and his sure sense of color played with the richness of nuance. Schiele's pantheistic ecstasies have the milky brightness of fine marbling in opal.

Hans Tietze,
in *Die Bildende Kunst,*
vol. 2, July 1919

The Body as One Huge Wound

No doubt about it: a style which allows everything to be contaminated by ornament and gives it control over human actions and passions has no room for cries of pain, for tragedy, for a false note; on the contrary it will blend them into a general harmony. That is what Klimt, with the exception of his *Jurisprudence,* did throughout his life. . . . The dialectically reverse position could be called ascetic, but retreat is not

a response, and abstention solves no problems. The liberating impulse that sprang from the art of Gerstl, Kokoschka and Schiele was not a renunciation of ornament, but a violent desire to escape from the gilded cage of civilization and its ornamental harmony, to jump into the virgin forest of uninhibited urges. . . . To know the flesh rather than polish it, to obliterate it within ornament, or kill it in asceticism: this was the new radicalism around 1908, which did not yet have a name but would later come to be known as "expressionism." This desire for knowledge of the senses legitimized the artist's desire to wound, unmask, violate and destroy.

. . . To what extent can the body radiate erotic feeling in its material form? This is what is shown in the work of Schiele, which like no other, combines flesh, skin, bones, muscles and tendons in a unique symbolism of desire and physical abandonment. . . . Rather than the dialogue studied by Kokoschka, he preferred the monologue of autoeroticism. This exploration began with little girls presenting their sexual organs for experimentation, and led to self-portraits, a mode of expression of a type that combines artistic apprenticeship with narcissistic role play. Whatever judgment one chooses to make of Schiele's obsessive preoccupation with representations of himself, it is clear that it bears the stigmata of a painful mortification by which the body is viewed as one huge wound. Thus the recognition of the flesh acquires a new dimension of accusation; its sorrowful symbolic language bears witness to the social taboos, which the artist knows he is in the habit of breaking. This long series of self-portraits gives us an image of the struggle in which his environment compelled him to engage, in the form of a degradation of the body, a permanent torment that he had only one way of resisting: his work. . . .

The religious dimension to this recognition of the flesh came from Austrian Catholicism, which took the prologue to St. John's Gospel literally. In this culture (as in no other country apart from Spain), the Word was made flesh and was resistant to the asceticism of abstraction. . . . It would be wrong to make a comparison with the precise procedures preceding the burial of the Habsburg sovereigns as shown at Hermann Nitsch's Orgy Mystery Theater. Here the act of artistic creation was a bearer of hope for salvation, which enables us to carry our analysis through to the present day. I am thinking of Rainer, Pichler and Frohner, of Brus, Nisch and Mühl, Valie Export and Maria Lassnig. . . . It is not merely a matter of a theme, but of the symbol of the Austrian contribution to the painting of our time . . . that is to say, the merciless interrogation of the creature. If we study the European context, we will see that this symbol is found nowhere else with the same intensity: not in the German Expressionists, or in the avant-garde in Barcelona, Paris, Prague, Milan or Moscow. It is the tangible sign of Austria's contribution to modernity.

Werner Hofmann,
"Den Fleisch erkennen," in
Ornament und Askese,
Christian Brandstätter,
Vienna, 1985

Bibliography

Works by Egon Schiele

—*Egon Schiele im Gefängnis, Akademische Druck- und Verlagsanstalt,* 1990.
—*I, Eternal Child = Ich ewiges Kind,* Grove Press, 1988.

Catalogues Raisonnés

—Jane Kallir, *Egon Schiele: Drawings and Watercolors,* Thames & Hudson, 2003.
—Jane Kallir, *Egon Schiele: The Complete Works,* new expanded edition, Abrams, 1998.
—Gianfranco Malafarina, *Tout l'oeuvre peint de Schiele,* Flammarion, 1983.

Studies

—Klaus Albrecht Schröder, *Eros and Passion,* Prestel Publishing, 2006.
—Tobias G. Natter, *The Naked Truth: Klimt, Schiele, Kokoschka and Other Scandals,* Prestel Publishing, 2005.
—*Egon Schiele & Arthur Roessler: der Künstler und sein Förderer: Kunst und Networking im frühen 20. Jahrhundert,* Hatje Cantz, 2004.
—Wolfgang Georg Fischer, *Schiele,* Taschen, 2004.
—Jane Kallir, *Egon Schiele: Life and Work,* Abrams, 2003.
—Tobias G. Natter, *Die Welt von Klimt, Schiele und Kokoschka: Sammler und Mäzene,* Dumont, 2003.
—Kai Artinger, *Egon Schiele: sa vie et son oeuvre,* Könemann, 2000.
—*Schiele, 1890–1918,* Cercle d'art, 1999.
—Christopher Short, *Schiele,* Phaidon Press, 1997.
—Alessandra Comini, *Egon Schiele, 27 Masterworks,* Abrams, 1996.
—Reinhard Steiner, *Egon Schiele 1890–1918: The Midnight Soul of the Artist,* Taschen, 1996.
—*Sehnsucht nach Glück: Wiens Aufbruch in die Moderne: Klimt, Kokoschka, Schiele,* G. Hatje, 1995.
—Frank Whitford, *Egon Schiele,* Thames & Hudson, 1995.
—Patrick Werkner (ed.), *Art, Sexuality and Viennese Modernism,* Sposs, 1994.
—Danielle Knafo, *Egon Schiele: A Self in Creation,* Associated University Presses, 1993.
—Christian Michael Nebehay, *Egon Schiele: du croquis au tableau. Les carnets,* Adam Biro, 1990.
—Sabarsky, Serge, *Egon Schiele: 1890–1918. Cent oeuvres sur papier,* Paris, Musée-Galerie de la Seita, Herscher, 1985.
—Christian Michael Nebehay, *Egon Schiele 1890–1918. Leben, Briefe, Gedichte,* Salzburg and Vienna, Residenz Verlag, 1979.
—Alessandra Comini, *Egon Schiele,* George Braziller, 1976.
—Alessandra Comini, *Egon Schiele's Portraits,* University of California Press, 1974.
—Alessandra Comini, *Schiele in Prison,* New York Graphic Society, 1973.
—Egon Schiele, *Leben und Werk: Ausstellung zur 50. Wiederkehr seines Todestages,* Vienna, Historisches Museum der Stadt, 1968.
—Werner Hofmann, Egon Schiele. *Die Familie,* Stuttgart, Philipp Reclam Verlag, 1968.

Exhibition Catalogues

—*Klimt, Schiele, Moser, Kokoschka,* Vienna 1900, exh. cat. Galeries nationales du Grand Palais, Paris, October 5, 2005–February 23, 2006, Réunion des musées nationaux, 2005.
—*Egon Schiele: Love and Death,* exh. cat. Van Gogh Museum, Amsterdam, March 25–June 19, 2005, Paris, Gallimard, 2005.
—*Egon Schiele: Landscapes,* exh. cat. Leopold Museum, Vienna, September 17, 2004–January 31, 2005, Prestel, 2004.
—*La Vérité nue (The Naked Truth): Gerstl, Kokoschka, Schiele, Boeckl,* texts by Dina Vierny, Caroline Messensee, Olivier Lorquin, Bertrand Lorquin, exh. cat. Réunion des musées nationaux–Musée Maillol, 2001.
—*Schiele,* exh. cat. Fondation Pierre-Gianadda, Martigny, Switzerland, February 3–May 14, 1995.
—*Vienna, 1880–1938. L'Apocalypse joyeuse* (The Joyous Apocalypse), edited by Jean Clair, exh. cat. Pompidou Center in 1986, Paris, Éditions du Centre Pompidou, 1986.

Museum Collections

Although Egon Schiele's works can be seen in the major museums, most are part of private collections. The museums of Austria do, however, hold large collections that are representative of his career.

Graphische Sammlung Albertina, Vienna

The Albertina's collection of works by Egon Schiele is unique in the world: it contains more than 150 drawings and watercolors, sketchbooks, and a large archive collection on the artist. From 1917 on, the

Staatsgalerie in Vienna bought drawings from Schiele, and these now form part of the Albertina collection. It has also benefited from the acquisition of works from the Arthur Roessler collection and the Heinrich Benesch estate, and from gifts, including those of Erich Lederer. Two books have been written on the Albertina archive by Christian Nebehay, the son of Gustav Nebehay (1881–1935), an art dealer who met Egon Schiele in 1917.

Leopold Museum, Vienna

Starting in 1945–50, the art historian Rudolf Leopold built up one of the largest collections of Schiele's works. Many of them were owned by Austrians who had emigrated, and after nearly forty years of tireless efforts to acquire them, Leopold had amassed more than forty oil paintings and over two hundred drawings, watercolors, and gouaches by the painter. Not only did Leopold assemble this collection, he can

also be credited with having made Schiele and the Austrian art of the nineteenth and twentieth centuries known outside Austria.

Österreichische Galerie Belvedere, Vienna

In addition to works by Gustav Klimt, including *The Kiss,* and by Oskar Kokoschka, the Belvedere museum has a number of works by Egon Schiele, such as *Death and the Maiden, The Family, Portrait of Hugo Koller,* and *Windows (Façade of a House),* as well as some preparatory sketches and works on paper.

Wien Museum, Vienna

Most of the Wien Museum's works by Egon Schiele come from the collection of the writer and critic Arthur Roessler, and include *Portrait of Arthur Roessler, Portrait of Otto Wagner, Sunflower II,* and *The Artist's Bedroom in Neulengbach.*

Table of Illustrations

Index

PHOTOGRAPH CREDITS

ACKNOWLEDGMENTS

This book owes its existence to the exhibition that took place in 1985 at the Pompidou Center, *Vienna 1880–1938, L'Apocalypse Joyeuse*. The author would therefore first like to express his gratitude to Jean Clair. Thanks also to Annie Perez, Olivier Gabet, Adrien Goetz, and Raphaël Sadouki for their suggestions, encouragement and help with proof-reading, and to Christian Witt-Döring, who has helped to sustain my love for Vienna by organizing memorable exhibitions and catalogues. I would also like to thank all the other scholars in Vienna who have signposted my way into their city, archives and museums: Paul Asenbaum, Galerie Asenbaum; Antonia Herschelman, Albertina; Tobias G. Natter, Österreichische Galerie Belvedere; Ursula Stoch, Historisches Museum Wien. Many thanks also to my patient research assistant, Anne Muraz, and to Doryck Sembaz, without whose daily presence and invaluable advice this book could not have been written. The publisher would like to thank Christian Brandstätter, and the Galerie St Etienne in New York.

Jean Louis Gaillemin is an art historian at the University of Paris IV–Sorbonne. A journalist and co-founder of *Beaux-Arts Magazine* and creator and director of *L'Objet d'Art*, he has contributed to numerous international magazines, including *World of Interiors*, *FMR*, and *AD*. His dissertation on architecture and Surrealism was followed with the publication of his *Dali, Désirs, inassouvis, du purisme au surréalisme, 1925–1935* (2004). In the area of decorative arts he has published a volume on decorators of the 1940s (2001), *Sièges d'Emilio Terry, projets* (2001), and *André Dubreuil* (2005). His familiarity with Vienna around 1900 gives him a unique perspective for situating Schiele within his intellectual and aesthetic milieu.

Translated from the French
Egon Schiele: Narcisse écorché by Liz Nash

First published in the United Kingdom in 2006
by Thames & Hudson Ltd, 181A High Holborn,
London WC1V 7QX

www.thamesandhudson.com

British Library Cataloguing-in-Publication Data
A catalogue record for this book is available
from the British Library

ISBN-13: 978-0-500- 30121-0
ISBN-10: 0-500-30121-2

Printed and bound in Italy by Editoriale Lloyd, Trieste